IMAGES
of Rail

RAILS AROUND
McCLOUD

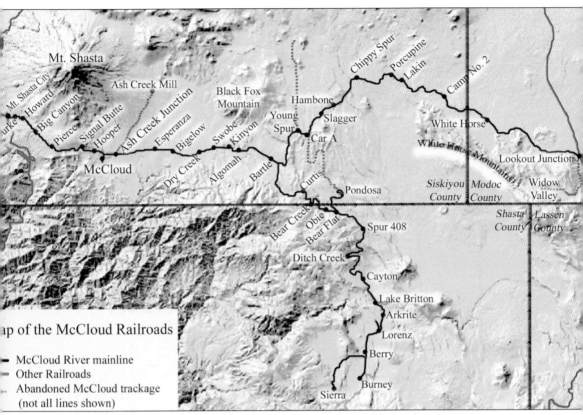

Mt. Shasta

Ash Creek Mill

Mt. Shasta City

Howard

Burke

Big Canyon

Pierce

Signal Butte

Hooper

Ash Creek Junction

Esperanza

Bigelow

Swobe

Kinyon

Black Fox Mountain

Hambone

Young Spur

Slagger

Car A

Chippy Spur

Porcupine

Lakin

Camp No. 2

White Horse

White Horse Mountains

Lookout Junction

McCloud

Dry Creek

Algomah

Bartle

Curtis

Pondosa

Siskiyou County

Modoc County

Widow Valley

Shasta County

Lassen County

Bear Creek

Obie

Bear Flat

Spur 408

Ditch Creek

Cayton

Lake Britton

Arkrite

Lorenz

Berry

Burney

Sierra

ap of the McCloud Railroads

— McCloud River mainline
— Other Railroads
.. Abandoned McCloud trackage
 (not all lines shown)

This map shows the major lines and station points of the McCloud railroads.

ON THE COVER: The crew of McCloud River Railroad locomotive No. 15 has gathered around the pilot for the photographer. The train is stopped on one of the impressive trestles on the side of Black Fox Mountain northwest of Bartle. (Jeff Moore collection.)

IMAGES
of Rail

RAILS AROUND
McCLOUD

Jeff Moore

ARCADIA
PUBLISHING

Published by Arcadia Publishing
Charleston SC, Chicago IL, Portsmouth NH, San Francisco CA

Printed in the United States of America

Library of Congress Catalog Card Number: 2007928549

For all general information contact Arcadia Publishing at:
Telephone 843-853-2070
Fax 843-853-0044
E-mail sales@arcadiapublishing.com
For customer service and orders:
Toll-Free 1-888-313-2665

Visit us on the Internet at www.arcadiapublishing.com

To all McCloud railroaders

CONTENTS

ACKNOWLEDGMENTS

This book would not have been possible without two groups of people. The first is a group of past and present McCloud railroaders, chiefly Malen Johnson, Bob Sharrah, Roger Titus, Travis Berryman, George Landrock, Michael Zetocha, and Carol Julien. The employees have often been one of the biggest strengths of the McCloud railroads, and I thank you for sharing your memories and in some cases your photograph collections. The second group is the Heritage Junction Museum of McCloud, Inc., with my biggest indebtedness to Norman Linn, Gerald Hoertling, and Wally Trapnell. The museum has preserved a large collection of McCloud history and very graciously opened their photograph and record archives for this project.

I would also like to thank several others who contributed material to this project, including Dennis Sullivan, Joe Bispo, Sean Zwaggerman, Jerry Lamper, Louis Thelen, Jack Neville, and Drew Jacksich. Thanks also must go to Devon Weston of Arcadia Publishing for asking me to pull this project together and for answering all of my questions and helping me through the process. I hope I did not miss anyone. Thank you all.

Finally, I must thank my wife, Alicia, and my daughter Kinyon for all your love, support, and above all patience during this project.

INTRODUCTION

Thirty miles off the northwest coastline of the United States, the westward moving North American plate, which underlies the continent, collides with the eastward moving Juan de Fuca plate, which underlies the northeastern Pacific Ocean. At the collision point, the Juan de Fuca plate is forced under the North American plate in a process known as subduction. The Juan de Fuca plate descends downward beneath the North American plate to a point roughly 190 miles below the earth's surface, where the increasing temperature melts the rock. The molten rock, called magma, then works through cracks in the North American plate to the surface. Over a period of several million years, the resulting volcanic activity built the Cascade Mountain Range, which stretches northward from California to Canada.

Mount Shasta's 14,162-foot-tall peak dominates the southern end of the Cascade Range. The great peak dwarfs the surrounding landscape, which includes the neighboring volcanoes of the Medicine Lake Highlands 30 miles to the east and Mount Lassen 80 miles to the south. Many other volcanic features, such as lava flows and cinder cones, fill the land between the mountains. Volcanic rocks quickly weather to form some of the most productive soils found on earth, especially when mixed with the ash fall and mudflows characteristic of the major volcanic eruptions.

Storm systems rolling eastward off the Pacific Ocean rise as they pass over the Cascade Range. The clouds are forced to deposit most of their moisture content on the west slopes of the Cascades. The eastern slopes receive significantly less precipitation, and what does come falls mostly in the form of winter snow. The precipitation received, in conjunction with the soils, is enough to support dry forests dominated by sugar pine, ponderosa pine, Douglas fir, incense cedar, and white fir. These forests exist in a 50-mile-wide swath nestled against the eastern flank of the Cascades.

Southeast of Mount Shasta lies the broad valley of the McCloud River. The local native populations thrived in the valley for centuries on the bountiful natural resources that the area offered, with fish being an especially important staple of their diet. Spain laid the first European ownership claims to the region, with title passing to Mexico after their revolution. The United States took possession of the region in 1848 under the terms of the Treaty of Guadalupe Hidalgo. The same year also saw the discovery of gold in the foothills east of Sacramento, which led to the great Gold Rush and the subsequent establishment of the state of California. The flood of prospectors spread out to all corners of the new state, and in 1852, one named Abraham Thompson discovered gold in a narrow valley 40 miles northwest of Mount Shasta. Within six weeks 2,000 people moved to the new camp, which became known as Yreka. The influx of people prompted the creation of Siskiyou County in 1852, with Yreka named the county seat.

Settlement of the region gradually expanded over the next several decades. Farmers broke the land in the valleys scattered through the area, especially in Fall River and Big Valleys far to the southeast. Other settlements formed around the wagon roads that connected the area with the outside world. Many people admired the fine forests, but the lack of economic transportation to distant markets limited the exploitation of the forests to local uses.

In the early 1860s, two railroads started constructing a rail line projected to connect California and Oregon. The California and Oregon started northward from Marysville, California, while the Oregon and California started southward from Oregon's Willamette Valley. The two railroads met in Ashland, Oregon, in December 1887. The Central Pacific, builder of the western portion of the transcontinental railroad, gained control of both companies. The construction and early operations of the railroad consumed enormous quantities of wood, much of which had to be produced locally. Many new sawmills appeared along the line to meet the need. The transportation to markets that the railroad provided ensured the continued survival of some of these companies, although the wildly fluctuating lumber market of the 1880s and early 1890s forced many of them to close. Those that lived started building logging railroads to transport raw logs from the woods to the sawmills, but the Sacramento River Canyon walls severely limited where these railroads could go.

Several lumbermen looked longingly eastward over the shoulder of Mount Shasta at the stands of timber in the McCloud River drainage. The timber lay on the wrong side of the mountain from the railroad, which made any large-scale commercial exploitation an expensive and risky proposition. Several parties were willing to try their hands, however, with the Red Cross Lumber Company making the first attempt. In 1887, that company built a small mill near a ranch and hotel operated by Abraham and Jerome Bartle. The company hoped to build a railroad from a connection with the Southern Pacific (successor to the Central Pacific) up Soda Creek to the McCloud River, but they only got four miles spiked down when a crash in the lumber market closed the company. The Siskiyou Lumber Company made the second attempt, with a small sawmill in operation along the banks of Ash Creek on the eastern side of the mountain in 1891. High transportation costs and an unstable lumber market limited the mill to sporadic operations through the next several years.

A man named Ambrose Friday George made the third effort. In May and June of 1892, he moved a sawmill from Soda Creek eastward to a spot in the valley of Squaw Creek that he named Sugar Pine Park. George purchased a large steam-powered traction engine that he planned to use to move logs from the woods to his mill and then to move the finished lumber to the Southern Pacific mainline. George financed his venture with borrowed money, and once he commenced operations he found himself unable to cut lumber fast enough to satisfy his debts. Another crash in the lumber market forced Friday George into bankruptcy. Sugar Pine Park lapsed into silence in October 1894.

The Bank of Shasta County ended up with the ruins, and in June 1895 they held an initial auction to try selling off some of the properties. Low bids caused the auction to end early. However, in early 1896 the newly formed McCloud River Lumber Company, led in part by San Francisco businessmen George Scott and William Van Arsdale, purchased the old George properties. The new company renamed the camp Vandale, and in the fall of 1896 they started moving equipment for a new mill into the camp and roughing out a new railroad grade across the mountains to the west.

One

BEGINNINGS

The McCloud River Railroad Company came into formal existence on January 21, 1897. The new railroad took over construction and operation of the railroad that the closely affiliated McCloud River Lumber Company started building the year before. The incorporation documents envisioned a mainline running from a connection with the Central Pacific at Upton, California, eastward through Vandale to Alturas, California, with branches to Sisson and the Ash Creek mill. Construction on the railroad resumed in mid-April 1897, with the line completed to Vandale in late July. The McCloud River Railroad officially placed that line in service on August 1. Shortly after the railroad opened, the lumber company renamed Vandale to McCloud.

Construction did not stop at McCloud. The railroad would be used to bring logs from the woods east of McCloud to the sawmill, in addition to handling finished lumber to Upton. By 1899, the railroad had completed the planned line to the Ash Creek mill, which the McCloud River Lumber Company had acquired. The following year saw construction start eastward up the McCloud River valley in earnest, with the rails advancing at the same rate as lumber company harvest operations. The railroad reached Bartle, a small community formed around the Bartle Brother's ranch and hotel, in 1905. Railroad construction then followed the loggers into the vast lumber company holdings in the wilderness to the north.

The Ash Creek mill burned to the ground in August 1903, which prompted the lumber company to consolidate all sawmill operations into McCloud. The company built an entirely new sawmill complex on the northeastern edge of McCloud to replace the burned mill. The railroad built a new roundhouse and shop facility adjacent to the new sawmill. Logs and lumber traveling to and from the McCloud Mill dominated the freight traffic, with several smaller sawmills located on the railroad providing additional outbound lumber traffic. A daily passenger train operated between Upton and Bartle, where the railroad connected with a network of wagon routes that spread out through the sparsely populated areas to the south and east.

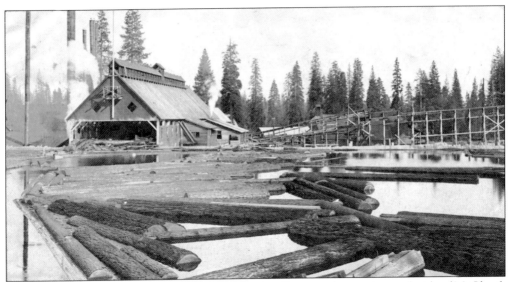

The first sawmill built by the McCloud River Lumber Company lay on the south side of McCloud. This view is looking south over the log pond. (Heritage Junction Museum.)

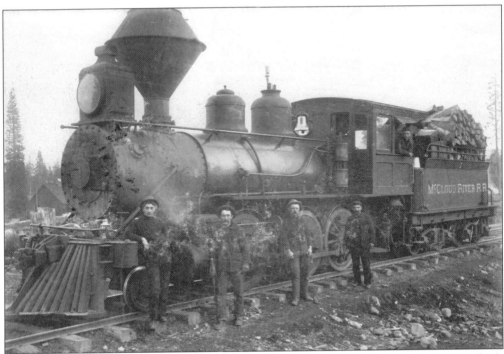

The McCloud River Railroad started operations with this 1891-built Baldwin 2-6-0, which worked for the California Railway in Oakland, California, before coming to McCloud. (Heritage Junction Museum.)

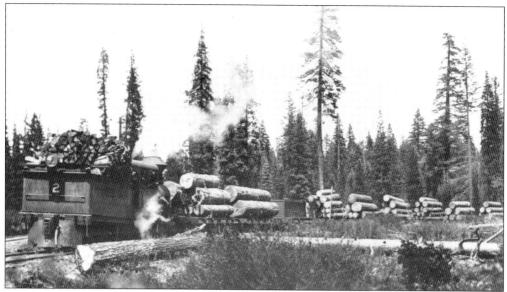

In 1897, the railroad purchased this new three-truck, Heisler-type geared locomotive. The machine suffered from many major design flaws that limited its operating abilities. The problems with No. 2 forced the new railroad to rely on locomotives leased from the Southern Pacific and prompted Heisler to provide a two-truck geared locomotive that eventually became McCloud River No. 3. The two Heislers did not last long on the railroad. (Heritage Junction Museum.)

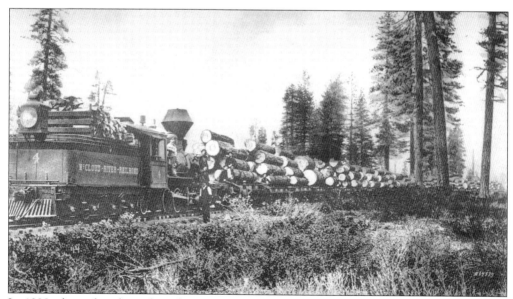

In 1898, the railroad purchased a new 2-6-2 type locomotive from Baldwin. The machine, assigned No. 4, set the pattern for most of the McCloud locomotive fleet that followed. (Dennis Sullivan collection.)

The original line west of McCloud featured switchbacks at Signal Butte, Big Canyon, and Upton. Line changes replaced the Big Canyon switchback in 1902, and the Upton switchback by 1907, but the Signal Butte one remained in place. Every train west of McCloud since has operated in reverse for half of each run. A train is seen here entering the Signal Butte switchback; the railroad used the turntable in the foreground to turn snowplows. (Heritage Junction Museum.)

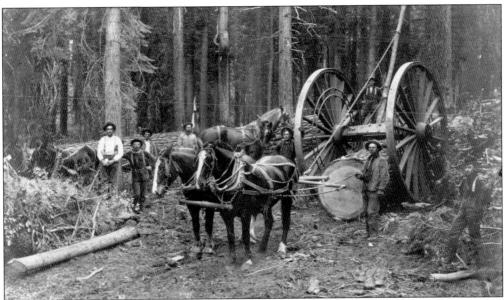

The McCloud River Lumber Company made extensive use of horse-drawn high wheels to move logs from the cutting site to the nearest railhead. This photograph shows a set of high wheels ready to start moving a log out of the woods. (Heritage Junction Museum.)

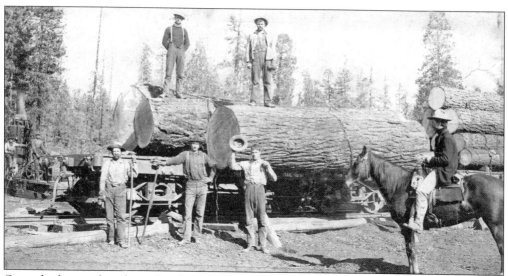

Once the log reaches the railroad, it must be loaded onto flatcars for shipment to the sawmill. In this photograph, a donkey engine is being used to roll the logs onto the cars; horses were also used for this task. (Heritage Junction Museum.)

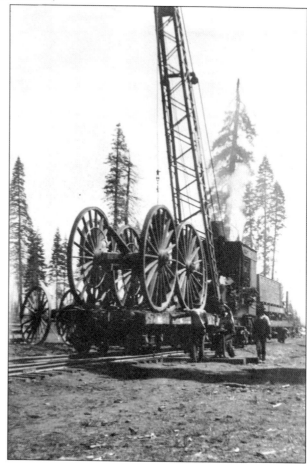

The log flats could also be used to move loads other than logs. In this photograph, one of the lumber company's two Brownhoist locomotive cranes is loading high wheels onto one flatcar, while the body of a wooden water tank rests on a second flat behind the crane. (Heritage Junction Museum.)

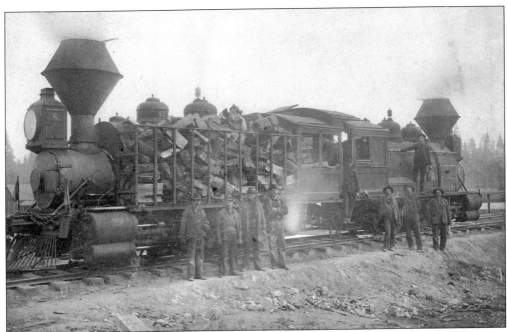

In 1900, Baldwin built McCloud River No. 6, which consisted of two 0-6-0 type locomotives semipermanently coupled to each other. The No. 6 proved to be too big of a locomotive for the McCloud railroad, which prompted the company to separate the machines into two locomotives, with one becoming No. 5 in the process. (Heritage Junction Museum.)

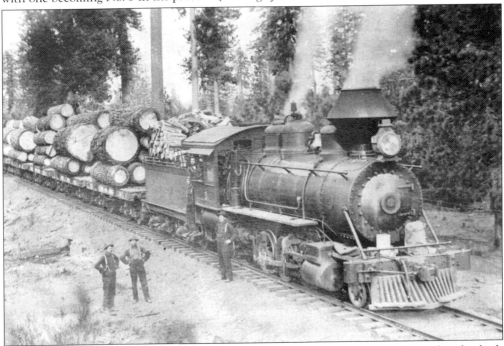

The year 1901 saw Baldwin deliver three more 2-6-2 steam locomotives to the railroad, which became McCloud River Nos. 8, 9, and 10. The No. 9 is seen here with a log train shortly after arriving on the railroad. (Jeff Moore collection.)

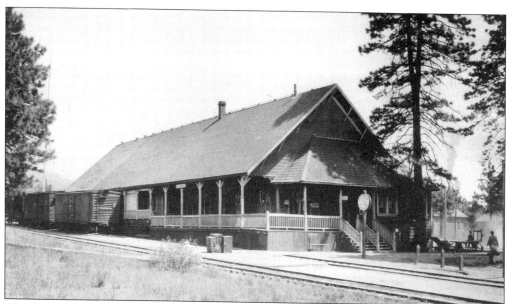

Charles R. Miller captured this fine photograph of the original depot and office building in McCloud. (Heritage Junction Museum.)

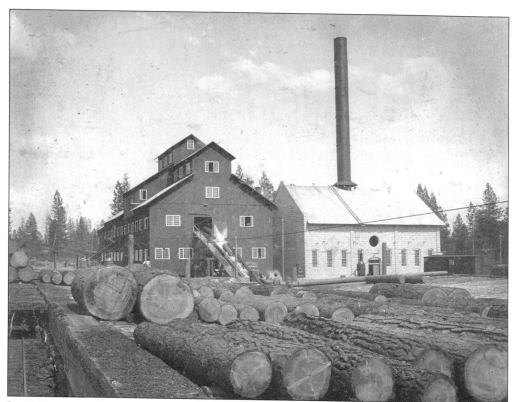

In 1903, the lumber company started construction of a new sawmill complex on McCloud's northeastern edge. The new sawmill and powerhouse are seen here shortly after going into operation. (Heritage Junction Museum.)

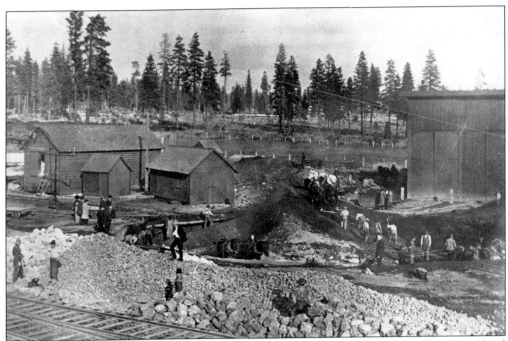

The railroad built a new yard, roundhouse, and shop facility on the north side of McCloud concurrent with and adjacent to the new sawmill. The above photograph shows a crew digging the pit for the turntable, while the photograph below shows the completed facilities. (Heritage Junction Museum.)

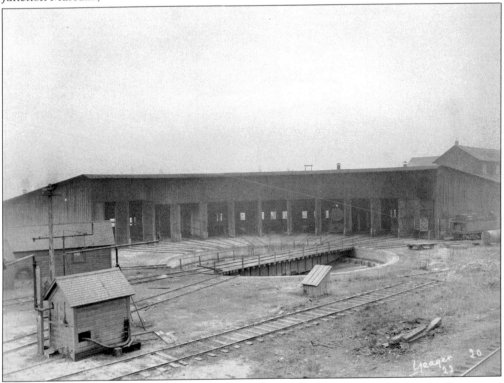

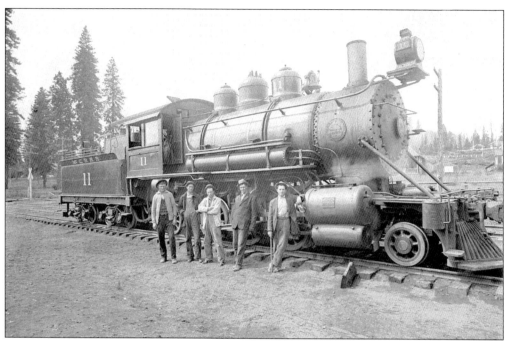

Pride and joy of the McCloud River Railroad in 1904 was locomotive No. 11, a new Baldwin 2-6-2 Vauclain compound. The compound cylinders greatly increased both the power and maintenance costs of the locomotive. (Heritage Junction Museum.)

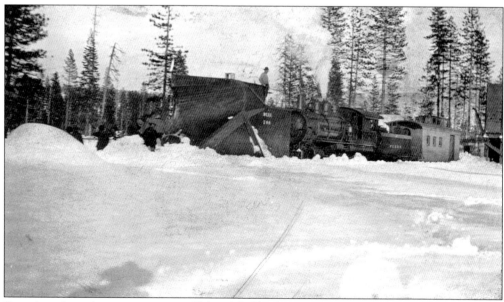

Snow has always been a major part of life in McCloud country. The No. 11 is seen here with plow No. 700 around 1905. (Heritage Junction Museum.)

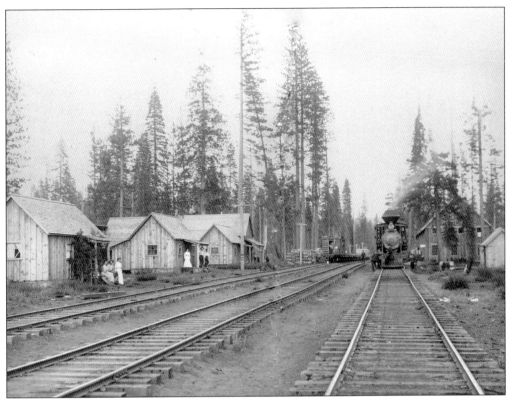

In 1905, the railroad reached the small ranching community of Bartle. The early facilities built around the new railroad can be seen in this photograph; the large building to the right is the depot and freight house. (Heritage Junction Museum.)

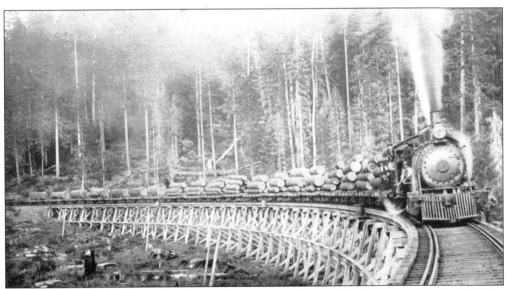

Two miles east of Bartle, the railroad built this long curving trestle at the base of Bartle Hill. The No. 8 is seen here with a train of logs harvested from lumber company holdings to the north. (Jeff Moore collection.)

Two

THE GLORY YEARS

The management team led by Scott and Van Arsdale got the McCloud companies off to a good start. However, in 1902 they placed the operations up for sale, and in 1907 a group of Minnesota capitalists, led by the Carpenter and Shevlin-Hixon interests, completed purchasing the McCloud companies. The new owners brought a substantial amount of capital that they invested in the continued expansion of the operations, which included relocating the railroad's western terminus from Upton to Sisson (later renamed Mount Shasta City). A strike by Italian employees in 1909 marred the early years of the new ownership, but the lessons learned by both sides helped the McCloud companies avoid much of the labor problems so prevalent in the lumber industry in the coming decades.

The continued expansion of the McCloud mill forced the loggers ever deeper into the woods. By the late 1910s, the logging railroad extended to the Medicine Lake Highlands. A series of private timberland purchases and a U.S. Forest Service timber sale sent the loggers and railroaders south and east of Bartle, with logging railroad trackage extending into western Modoc and eastern Shasta counties by the end of the 1920s. The increasing number of loggers with families caused the lumber company to abandon mobile log camps in favor of semipermanent communities at Pondosa and White Horse.

The railroad continued to expand eastward. In 1931, the lumber company extended its railroad beyond White Horse to a connection with the new Great Northern mainline south of Klamath Falls. The move gave the McCloud River companies two more connections with the outside world, as the Western Pacific Railroad had trackage rights over the Great Northern to also reach the McCloud River at Hambone. The Great Northern actually owned the trackage from Hambone to Lookout Junction, with the McCloud River Railroad handling all operations and maintenance and the lumber company retaining rights to operate their log trains.

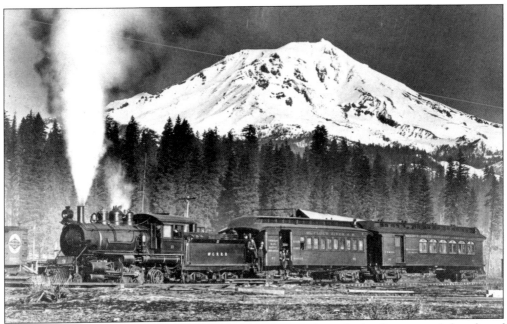

The McCloud River Railroad offered passenger service through the first several decades of operation. Locomotive No. 12 (formerly No. 1) normally powered the passenger trains, but on this day, No. 11 is pulling combination cars Nos. 01 and 02. Buses replaced the passenger train by the mid-1930s. (Ray Piltz collection, courtesy of Travis Berryman.)

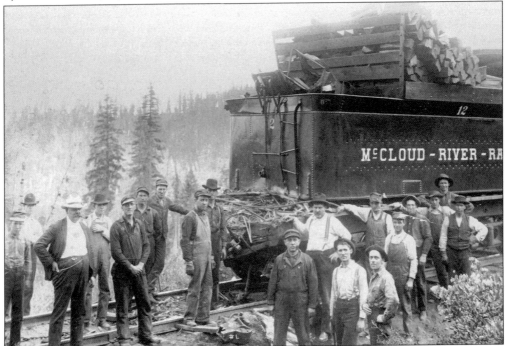

Railroading always has been a dangerous business, with the mountainous profile of the McCloud River increasing the propensity for accidents. The No. 12 has run into some sort of trouble near Pierce, and the crews have arrived to set things right again. (Heritage Junction Museum.)

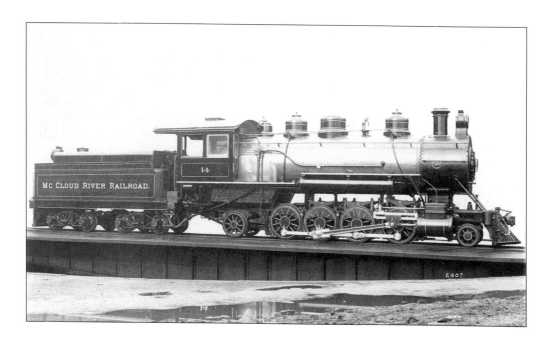

In July 1907, Baldwin turned out McCloud River locomotives No. 14 and No. 15. These versatile machines proved to be large enough to handle most log and lumber train assignments yet nimble enough to negotiate the sketchy track work typical of most logging railroads. The logging Mikado, as this type of locomotive became known, rapidly developed into one of the staples of the logging railroad industry through the first half of the 20th century. Baldwin and several other manufacturers built several hundred of these machines in weight classes ranging from 50 to 90 tons. The No. 14 is seen above in its builder's photograph and again below next to the water tank in McCloud toward the end of its career. (Above, Jerry Lamper collection; below, Jeff Moore collection.)

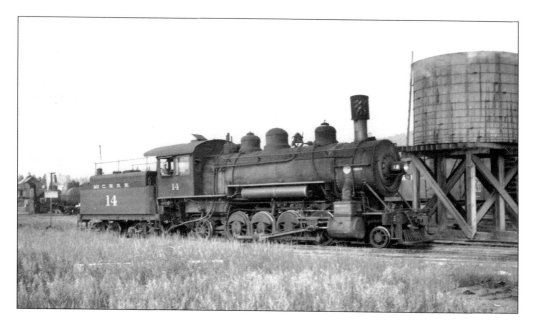

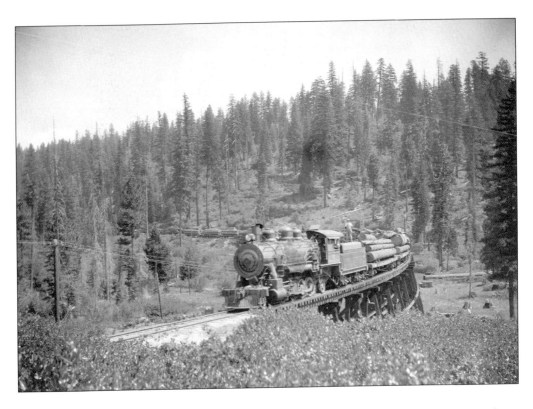

The above photograph shows the No. 15 bringing a trainload of logs across the trestle at the foot of Bartle Hill two miles east of Bartle, while the one below shows it later in its career at the sand house next to the McCloud roundhouse. (Above, Heritage Junction Museum; below, Jeff Moore collection.)

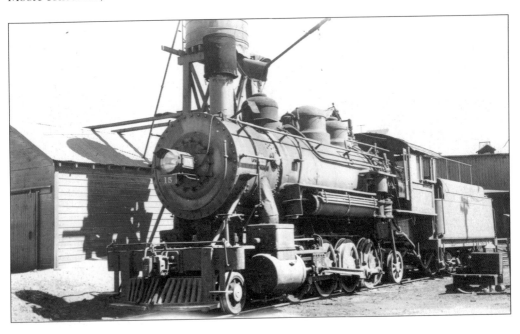

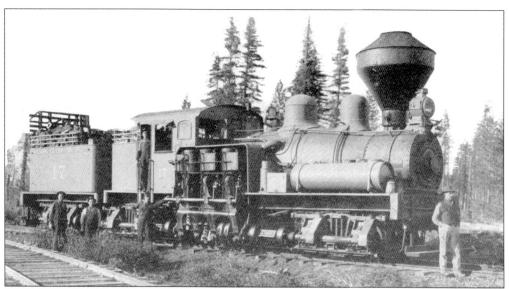

Around 1911, the lumber company started harvest operations in the Black Fox Mountain region northwest of Bartle. Black Fox Mountain provided some of the roughest topography the McCloud operations ever encountered, and the line built to reach the timber involved several spectacular trestles and six-percent grades. The railroad purchased two Shay-type geared locomotives, Nos. 16 and 17, in 1911 specifically to work this trackage. The above photograph is a promotional postcard produced by the lumber company featuring Shay No. 17, while the photograph below shows the No. 15 posed on one of the trestles built into the side of Black Fox Mountain. It appears to be the same train and location featured in the cover photograph. (Above, Jeff Moore collection; below, Dennis Sullivan collection.)

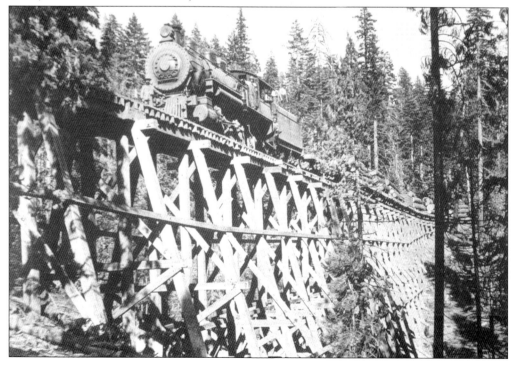

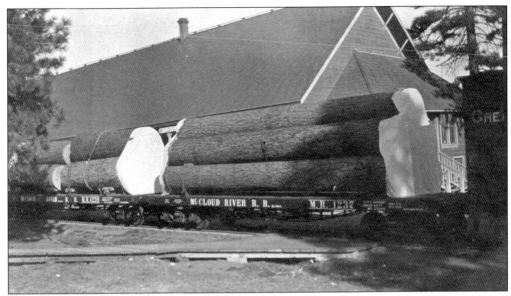

Throughout 1915, San Francisco hosted the Panama-Pacific Exposition to celebrate the completion of the Panama Canal. The organizers wanted every major California industry represented, and to that end the McCloud River Lumber Company joined with the neighboring Red River and Weed Lumber Companies to sponsor an exhibit featuring logging in the state's dry pine forests. McCloud's chief contribution to the exhibit was a display train featuring brand-new Baldwin logging Mikado No. 18, two flats loaded with some of the finest timber the McCloud woods could grow, a boxcar loaded with lumber produced by the McCloud mill, and caboose No. 015. The above photograph shows McCloud log flats Nos. 1237 and 1239 with their log loads posed next to the McCloud depot prior to departure. The photograph below shows the display train that appeared in a 1923 pocket calendar produced by the lumber company. (Above, Ray Piltz collection, courtesy of Travis Berryman; below, Heritage Junction Museum.)

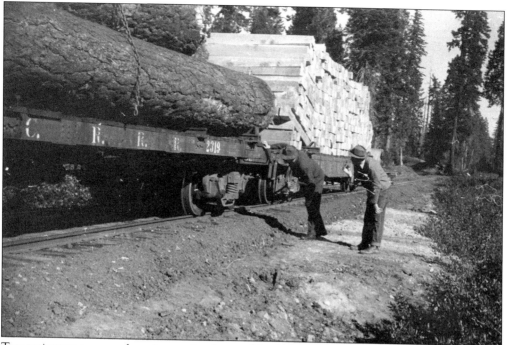

Two trainmen are seen here inspecting log car No. 2319, a 40-foot-long steel frame flatcar that the McCloud car shop rebuilt from an old boxcar in March 1935. The flatcar behind the No. 2319 carries a load of new ties, which are likely destined for the next log spur construction project in the woods. (Jeff Moore collection.)

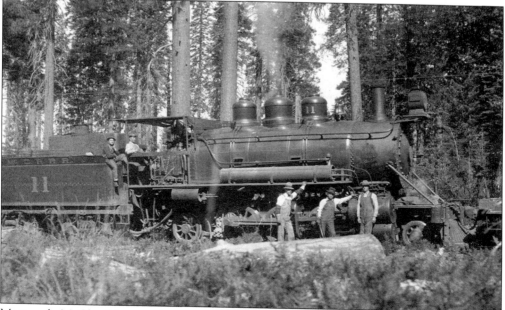

Most early McCloud locomotives originally carried wood cabs that were prone to burning or being damaged beyond repair in accidents. Locomotive No. 11 has lost its wood cab somewhere along the way, and a simple frame with a tarp stretched over the top had to suffice until a new steel cab could be installed. (Heritage Junction Museum.)

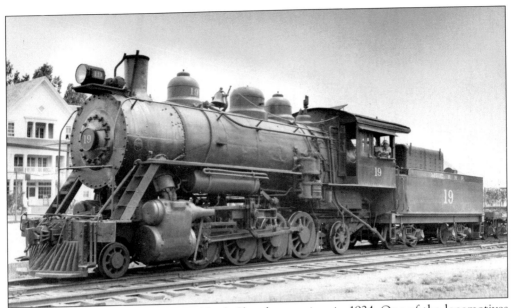

The railroad decided to sell the 1911-built Shay locomotives in 1924. One of the locomotives purchased to replace them was the No. 19, which served logging railroads in Arkansas and a mining firm in Mexico before coming to McCloud. Its south-of-the-border service garnered this locomotive the unofficial nickname of "Pancho." The No. 19 is seen here near the McCloud depot shortly after arriving on the property. (George Landrock collection.)

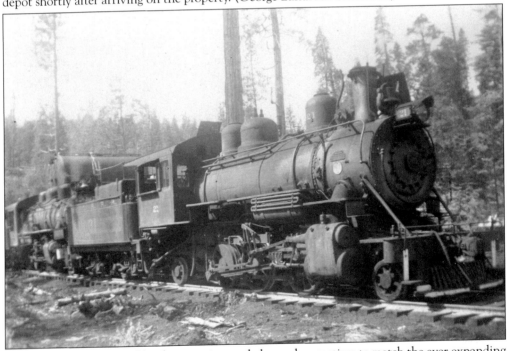

By the mid-1920s, the McCloud companies needed more locomotives to match the ever-expanding size and scope of the operations. In 1924, Baldwin built two new 2-6-2 type locomotives for the railroad that became Nos. 20 and 21. The No. 21 and a sister have paused at a water tank out in the woods to replenish their water supplies. (Dennis Sullivan collection.)

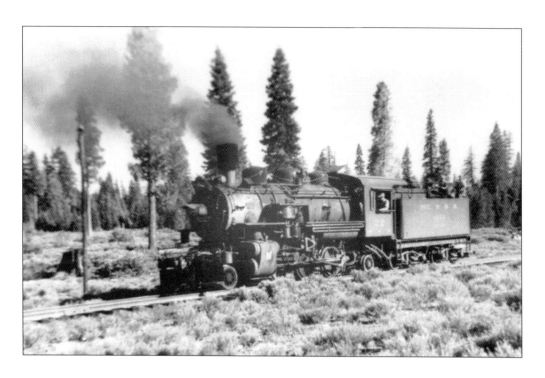

The 1924-built Baldwins proved to be ideally suited to the McCloud needs, and in 1925 the railroad ordered four similar machines from the American Locomotive Company (Alco). Alco built Nos. 22 and 23 in July 1925 at a cost of $18,450 each; Nos. 24 and 25 followed in November and cost $21,475 each. The above photograph shows the No. 22 near Hambone, while the one below depicts the No. 25 switching in the McCloud yards. The quartet would prove to be the last steam locomotives purchased new by the railroad. (Above, Dennis Sullivan collection; below, George Landrock collection.)

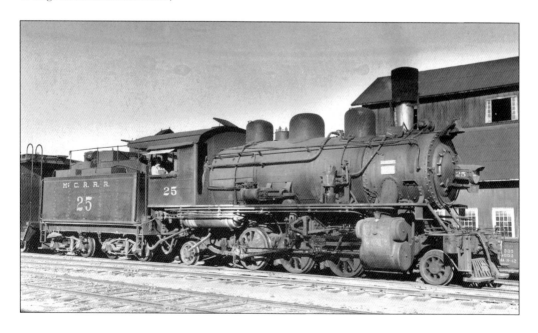

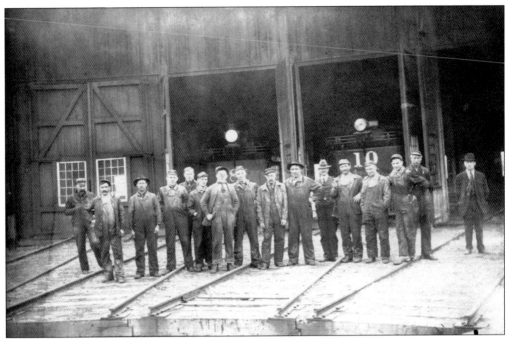

The railroad maintained a large shop in McCloud that handled locomotive and other equipment maintenance. The shop crew has come out in front of the roundhouse for a group portrait. Locomotives Nos. 8 and 10 occupy two of the stalls in the background. (Heritage Junction Museum.)

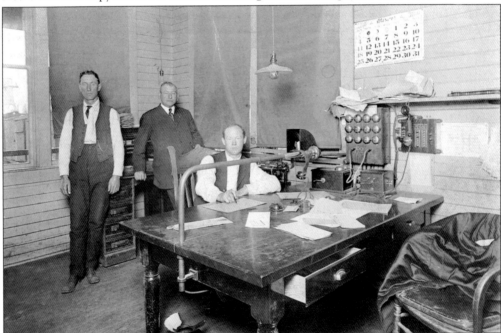

The train dispatching office is seen here in August 1919, judging by the calendar on the wall. The dispatcher coordinated operations of the entire railroad from this desk with a telegraph and telephone system the railroad used to communicate with train and track maintenance crews. (Heritage Junction Museum.)

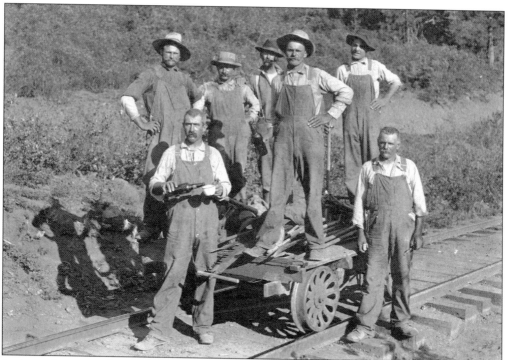

In the early years, railroads would station small groups of employees organized into section gangs at various points along the line. Each gang had a specific stretch of railroad it was assigned to maintain. This 1920s photograph shows the Bartle-based section gang posing with their tools on a hand cart. The man with the pipe in the back row is William Lyttleton. (Heritage Junction Museum.)

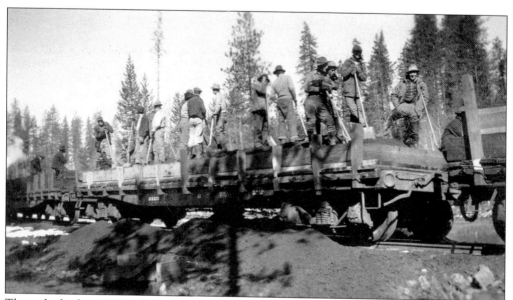

Through the late 1920s, the railroad moved ballast and fill material on flatcars outfitted with short gondola sides. A group of employees is seen here shoveling such material out of one of these cars. (Heritage Junction Museum.)

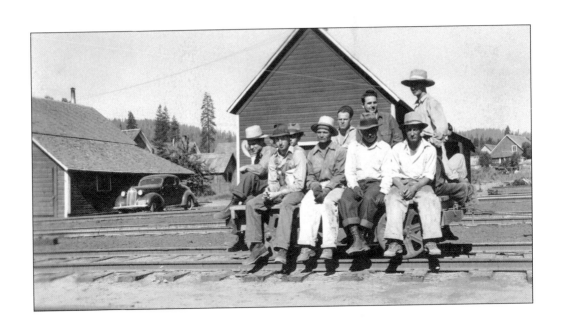

These two photographs show section gangs posed on the speeders they used to get around on the railroad. Both of these photographs were taken in the McCloud yards. (Heritage Junction Museum.)

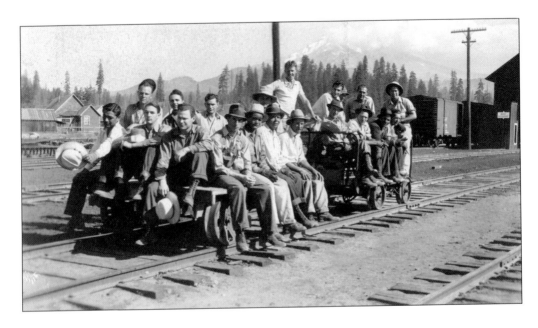

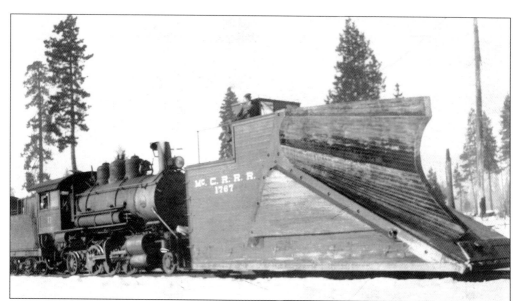

A trio of large wooden bucker plows served as the primary snow-removal tool on the McCloud railroads. The first was plow No. 700, which the railroad purchased or built before 1905 and renumbered No. 1701 by 1907. In 1911, the McCloud car shop built a second plow, also numbered 1701, to replace the original plow. The car shop then built plow No. 1767 in 1914. The No. 11 is seen here with the No. 1767 around 1922. (Dennis Sullivan collection.)

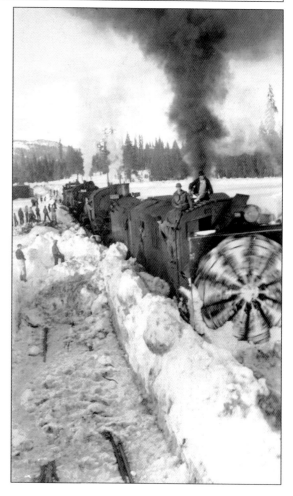

The bucker plows were sufficient to keep the railroad open in most years. When more snow fell than they could handle, the railroad would lease a rotary snowplow from the Southern Pacific to open the road, which happened in 1902, 1913, 1937, 1952, and 1969. The 1913 trip is seen here. (Sid Muma collection, courtesy of Travis Berryman.)

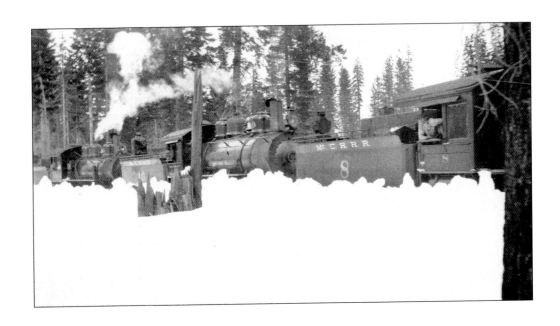

These are two more fine depictions of snow-removal operations. The above photograph shows locomotives Nos. 8, 10, and 4 standing in snow drifts, while in the image below two employees ride on the prow of one of the bucker plows. (Heritage Junction Museum.)

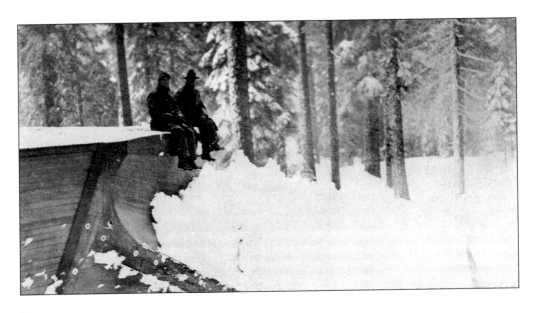

Although Hambone lay in a drier climate than McCloud, snow still posed a challenge to operations in the winter. The railroad built combination car No. 03, seen here sitting on the mainline at Hambone, in the McCloud car shop in November 1912. (Dennis Sullivan collection.)

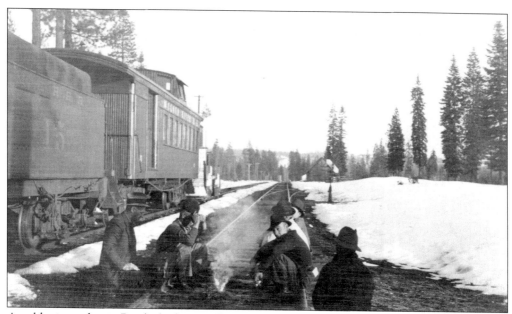

A cold winter day in Bartle finds a small group of railroaders huddled around a small fire built on the mainline. The presence of the cupola on coach No. 03 dates this photograph to sometime after 1932. (Heritage Junction Museum.)

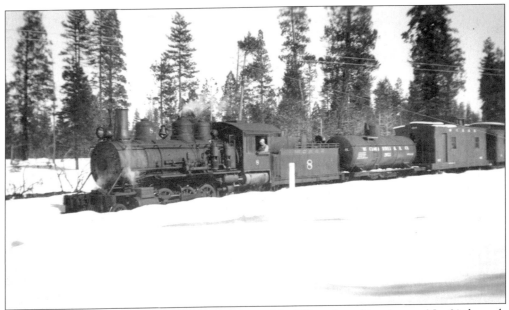

Locomotive No. 8 leads water car No. 2055, caboose No. 017, and combination car No. 01 through the snow. The presence of No. 2055 dates this photograph to sometime after the McCloud car shop built it in October 1934. (Dennis Sullivan collection.)

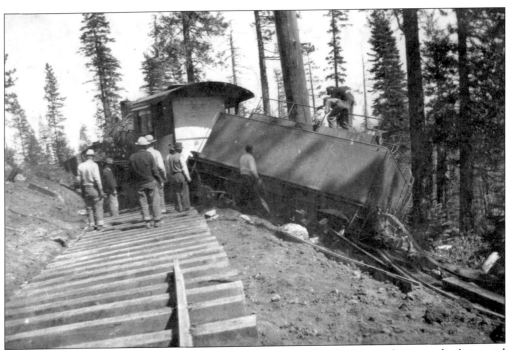

Locomotive No. 24 has stubbed its toe while running tender first somewhere on the line, and here crews are deciding on their next move. (Dennis Sullivan collection.)

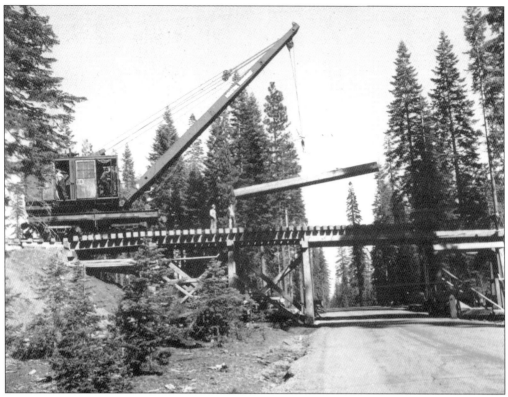

In late 1927, the lumber company moved a log camp named Pondosa from the current site of Hambone south to the Bear Creek drainage. The logging railroad trackage, built to reach the new harvest areas to the south and east of Ponderosa, crossed what would become Highway 89, first at grade and later with a bridge. The above photograph shows the lumber company's large crane No. 8 lifting beams into place, while the one below depicts the No. 25 crossing the same bridge. The railroad rebuilt and modified the bridge many times through the years, with it finally being torn out by 2000. (Above, Heritage Junction Museum; below, Jerry Lamper collection.)

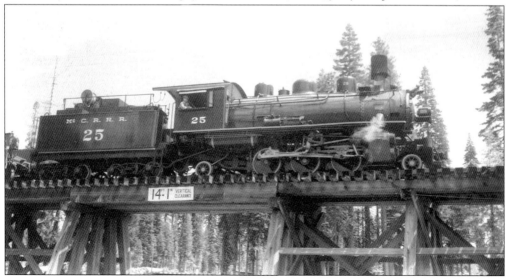

The lumber company intended for Pondosa to be the base for all loggers and railroaders working in the woods, and as such the community got all of the necessary facilities and services to support community and work life, including a large shop to maintain logging and railroad equipment. The above photograph shows crane No. 8 resting with some other equipment behind the shop, while the image below shows a McGiffert loader in close to the same location. (Dennis Sullivan collection.)

Locomotive No. 23 is seen here resting by the oil tanks outside the Pondosa engine house. (Dennis Sullivan collection.)

Caboose No. 025 started life as Great Northern No. X-378, with the McCloud River purchasing it in August 1939. A wreck at Car A destroyed the original car body, after which the railroad installed an old caboose body on the frame. In the late 1940s, the railroad built this car body. The car is seen here in Pondosa and survives today on the Yreka Western Railroad. (Dennis Sullivan collection.)

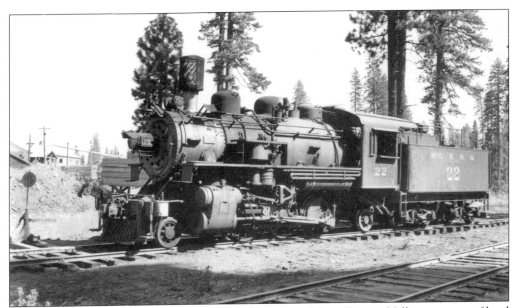

Around 1930, a man named Harry Horr moved his sawmill from Cayton Valley to a tract of land immediately adjacent to the lumber company's Pondosa camp. A succession of owners operated the Pondosa mill until 1980, when it finally closed. A portion of the Pondosa mill can be seen behind the No. 22. (Jeff Moore collection.)

The No. 25's engineer has paused for a portrait with his locomotive on a mountainside somewhere north of Bartle. (Dennis Sullivan collection.)

In 1929, the railroad tore down the original McCloud depot and replaced it with this impressive structure. The siding on the building is patterned after traditional log cabin siding and was a signature product of Shevlin Pine Sales, the parent corporation of the McCloud River Lumber Company. (Heritage Junction Museum.)

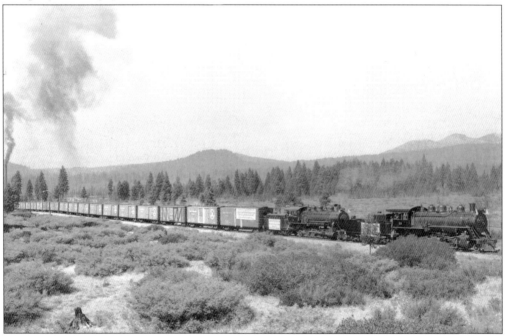

In 1928, the lumber company acquired 80,000 acres of timber located in western Modoc County. The lumber company established the White Horse camp to support harvest operations in this tract. In 1931, the logging railroad built to White Horse was extended to Lookout Junction, where it met a new Great Northern mainline built south from Klamath Falls. The first train of lumber to the new connection is seen here rolling eastbound out of McCloud behind locomotive Nos. 19 and 14. (Travis Berryman collection.)

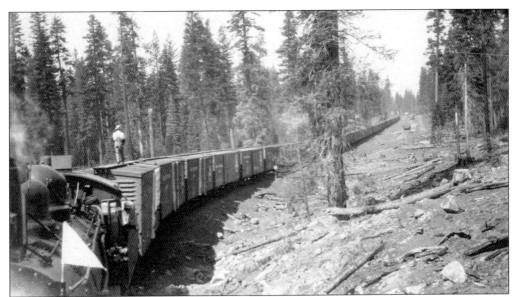

The first train to the new connection at Lookout has just passed through White Horse, which is visible through the trees in the distance. (Heritage Junction Museum.)

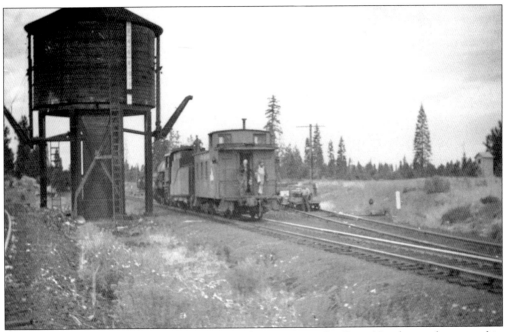

The final agreements for the opening of the Lookout Line saw the Great Northern take ownership of the Hambone-Lookout Junction trackage, with the McCloud River Railroad hired to operate the line. The McCloud River also interchanged cars with the Western Pacific at Lookout. This view is looking north at Lookout Junction, with a GN locomotive and caboose holding the main and the loop used to turn McCloud trains just visible on the left. (Ray Piltz photograph, courtesy of Travis Berryman.)

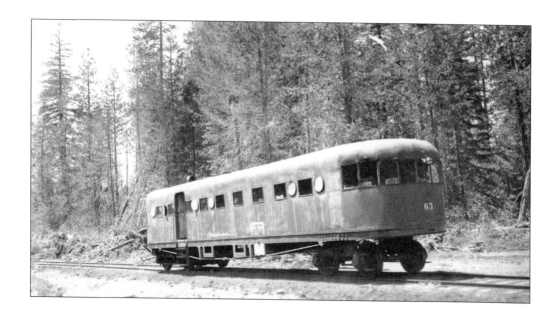

The sedentary nature of the camps at White Horse and Pondosa meant that logging operations would continue to move farther and farther into the woods. In the early 1930s, the lumber company built this homemade rail bus in the Pondosa shops. The car, known as the "Red Goose" to locals, was used to transport loggers to and from the woods. The lumber company initially numbered the car 52, with the number later changed to 63. The photograph above shows the car at Curtis later in its career. The photograph below depicts the remains of the car, which still exist at Kinyon. (Above, Ray Piltz collection, courtesy of Travis Berryman; below, Jeff Moore collection.)

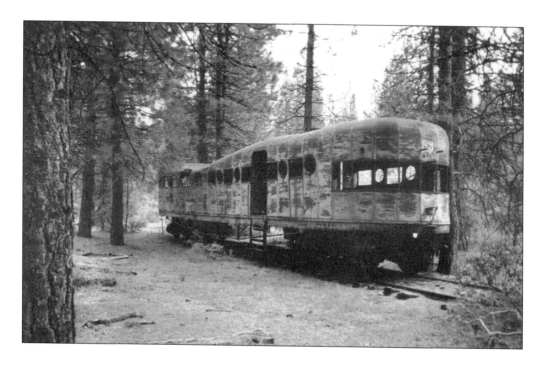

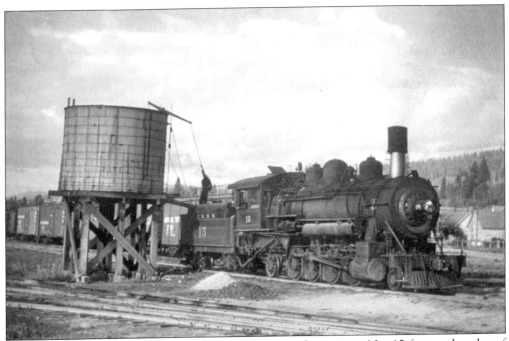

The morning of June 12, 1948, found a crew preparing locomotive No. 15 for another day of service over the railroad. The locomotive is seen here taking on water in the McCloud yard. (Joe Bispo photograph, courtesy of Travis Berryman.)

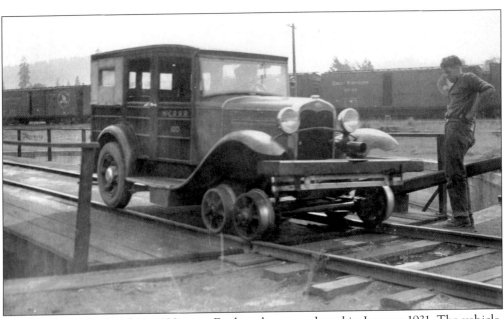

McCloud River Railroad No. 100 was a Ford track car purchased in January 1931. The vehicle, which had been specially equipped to run on railroad tracks, is seen here on the McCloud turntable with Albert Bishop. (Ray Piltz photograph, courtesy of Travis Berryman.)

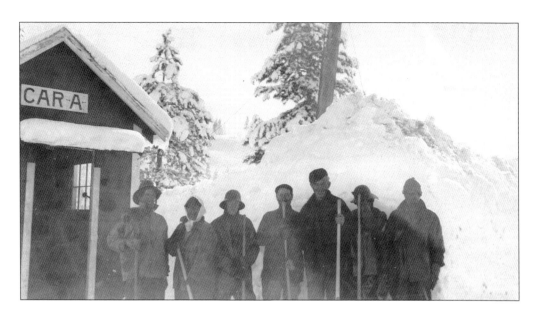

The winter of 1937–1938 proved to be one of the toughest ever experienced on the railroad, with most of the snowfall occurring in the Car A area. At one point during the storms, up to 50 railroaders spent several miserable days stranded at Car A while the railroad fought hard to reach them. The photograph above shows a group of employees at Car A, while the one below depicts some of the conditions the railroad faced in trying to open the railroad. (Heritage Junction Museum.)

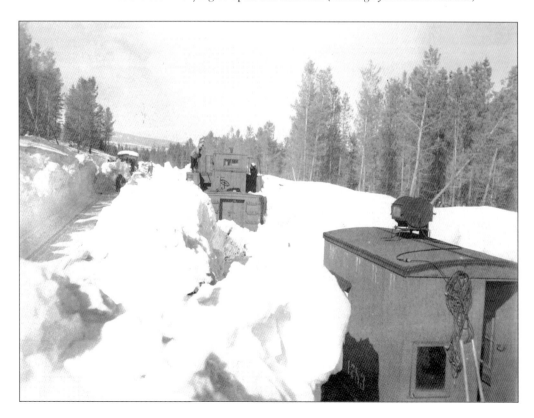

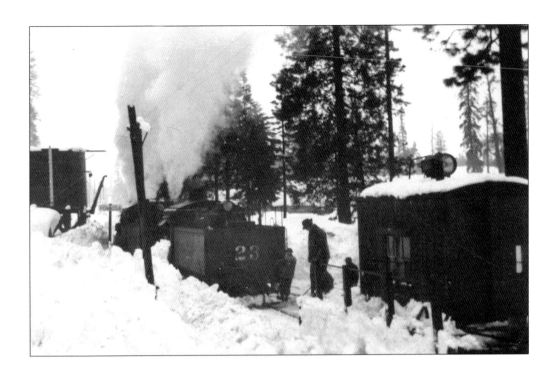

In addition to the two big bucker plows, the railroad also owned three smaller combination bucker/flanger plows and two straight flangers, with two more bucker/flangers added in 1938. The railroad built all of these plows in the McCloud car shop. The flanger blades on these smaller plows were used to clear snow accumulations from between the rails, which could compact into ice and derail trains if not removed. These two views depict snow removal operations in the logging camps with some of the smaller plows. (Dennis Sullivan collection.)

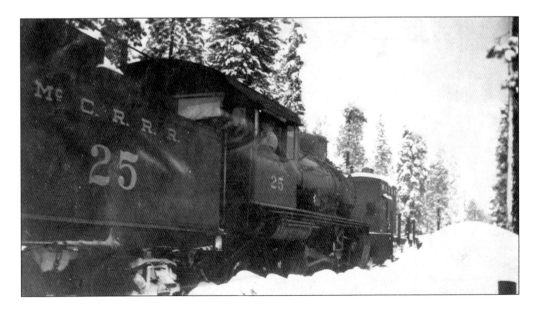

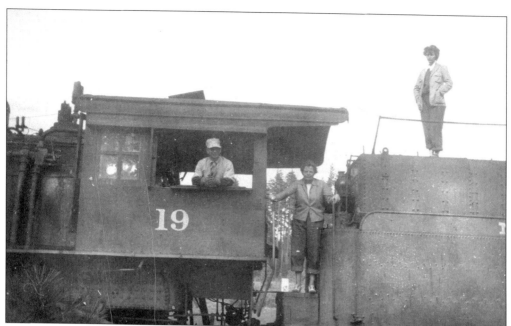

On this day, two schoolteachers headed for Pondosa had elected to ride with the crew of the No. 19. The pair is seen here along with the fireman during a stop at Bartle. (Dennis Sullivan collection.)

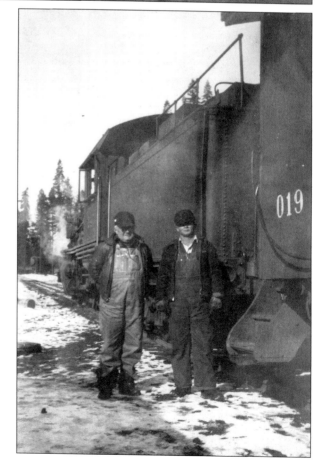

An old engineer and a young fireman strike a classic pose next to locomotive No. 24 and caboose No. 19, most likely at White Horse. (Dennis Sullivan collection.)

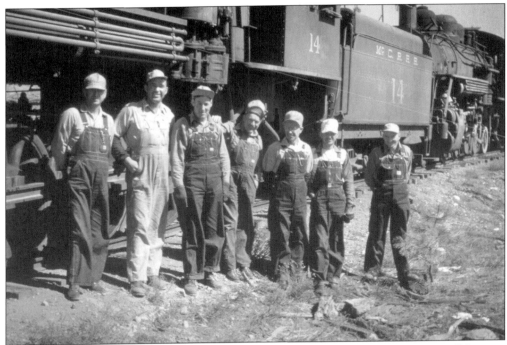

Seven McCloud railroaders pose next to locomotive No. 14 late in the steam era. (Heritage Junction Museum.)

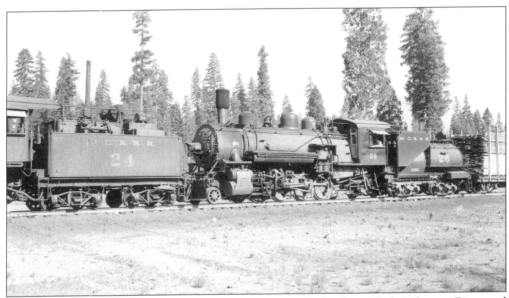

In 1938, the McCloud River purchased two Alco-built Mikados from Alaska's Copper River and Northwestern Railroad. The pair, Nos. 26 and 27, proved to be the heaviest steam locomotives owned by the company. The No. 26 is seen here moving a lumber train with the No. 24. (Jeff Moore collection.)

At the end of 1946, the lumber company moved the White Horse camp to Widow Valley, southeast of Lookout Junction. In 1948, the camp moved again, this time to Kinyon. Henry W. Brueckman took this photograph of Kinyon from a passing excursion train in 1962. The two cars on the siding carried tools, fuel, and parts to feed and care for tractors used in logging service. (Jack Neville collection.)

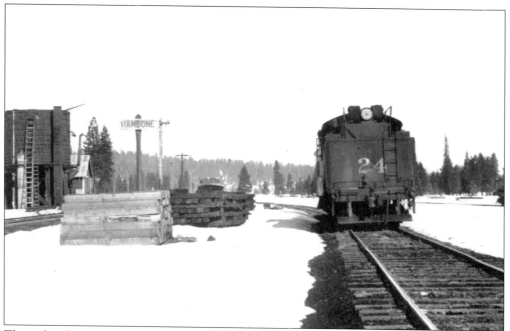

The railroad maintained a section-gang headquarters at Hambone for many years, and Elkins Cedar Mill also operated in the camp in the 1930s and 1940s. This photograph shows the No. 24 and a caboose waiting in the Hambone Yard. (Wally Trapnell collection.)

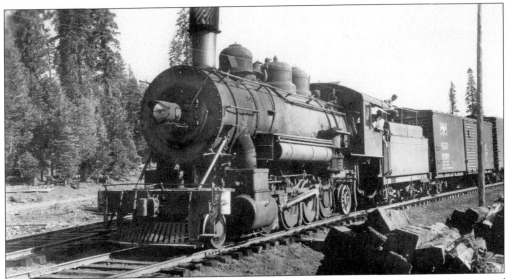

The last steam locomotives purchased by the McCloud River proved to be another pair of used logging Mikados, with the No. 16 arriving in 1939 and the No. 17 arriving in 1942. The railroad assigned the two locomotives the same numbers as the long-gone Shays. The No. 16 is seen here switching boxcars, most likely in Pondosa. (R. H. Carlson photograph, Jerry Lamper collection.)

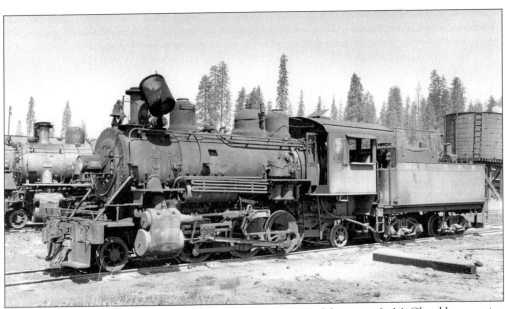

The No. 20 strikes a classic pose while showing off the typical features of a McCloud locomotive late in the steam era, including the headlight centered on the smoke box and the wire-screen spark arrestor. The hinged spark arrestor has been tipped off of the top of the stack. (Jerry Lamper collection.)

Three

FROM LOGS TO LUMBER

The journey starts with a single seed, one of many contained within a pinecone grown by a parent tree. The threats to the seed are many, and the odds against the seed ever growing into a tree are enormous. If the seed can make it to the ground without being eaten, it then must find a clear path through dead pine needles and other accumulated organic materials on the forest floor to find mineral soil. Even if the seed does sprout into a seedling, the path ahead is far from clear, as the mature trees around it tend to deprive the seedling of the sunlight it needs to grow. However, if enough moisture and sunlight reaches the forest floor, and if the seedling survives fires, wildlife, and other threats, it might grow into a mature tree.

Humans have always depended heavily on the resources derived from forest products. The population explosion and the rise of cities and industries at the beginning of the 20th century created a strong demand for lumber. The McCloud River Lumber Company was one of many operations meeting this demand, with the McCloud River Railroad starting the finished products on their journey to the customers.

The McCloud mill processed primarily sugar pine and ponderosa pine. Products included lumber, lath, beveled siding, and molding for the construction industry. Other products included sash and door cuttings and wooden boxes that the California citrus industry used to ship fruit to eastern markets. The company maintained a nationwide network of sales offices to market lumber and other products.

The following is a brief overview of some of the steps and technologies used in the process of turning trees into lumber in McCloud country during the glory years.

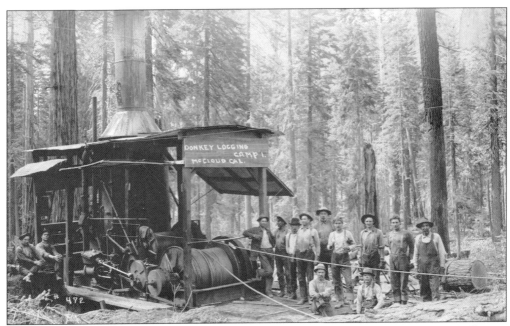

Moving a fallen tree from the woods to the sawmill always has been one of the biggest challenges facing loggers. The process starts with skidding each log to a central gathering point, generally known as the landing. The donkey engine was one of the principle machines used to skid logs; the above photograph shows one such machine in use in the McCloud woods. The image below depicts a Clyde Iron Works four-line skidder, a rail mounted piece of equipment that could skid logs into a landing from multiple directions. (Heritage Junction Museum.)

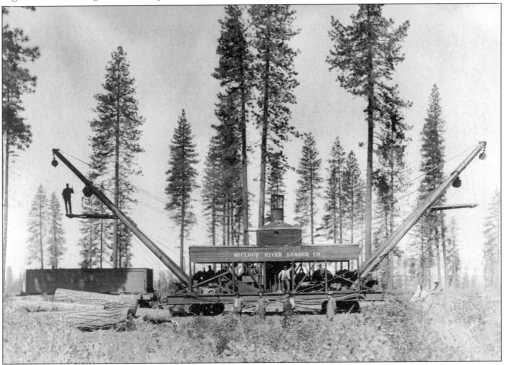

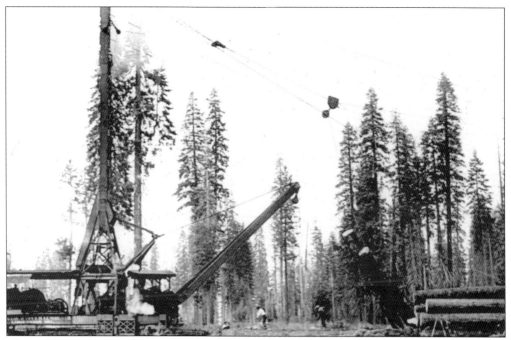

The Lidgerwood tower skidder was the ultimate combination of skidder and loader. The lumber company purchased one of these in the early 1920s. The steel spar pole could be used to lift part or all of a log off the ground while skidding it; in addition to that, the machine also had a heal boom to load logs onto log cars. (Heritage Junction Museum.)

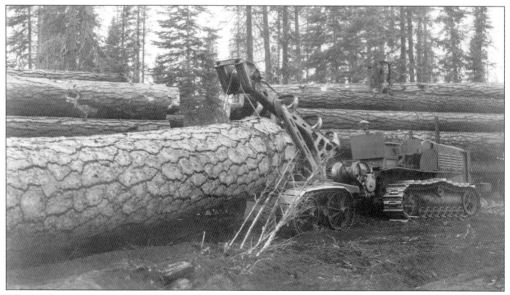

The lumber company started experimenting with tractors in logging service in the early 1920s, and within a decade animal and most steam power would be completely eliminated from the woods. A tractor is seen here bringing logs into the landing. The tracked logging arch carrying the log evolved from the high wheels of an earlier era. (Heritage Junction Museum.)

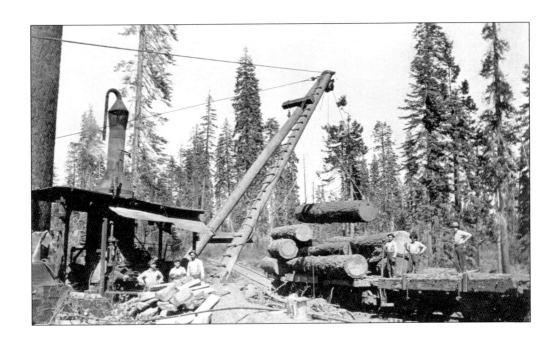

The McCloud River Lumber Company made extensive use of donkey loaders to lift logs onto log flats in the early years of the operations. These loaders featured an A-frame boom mounted to one end of a donkey engine. Two such machines are seen here loading log cars in the McCloud woods. (Heritage Junction Museum.)

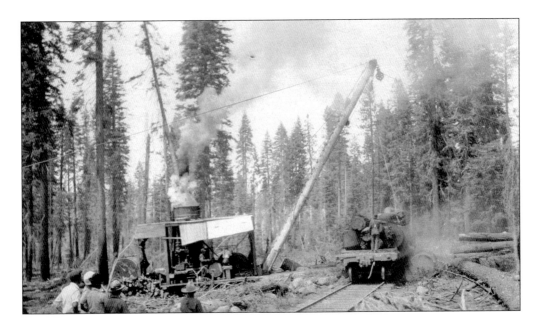

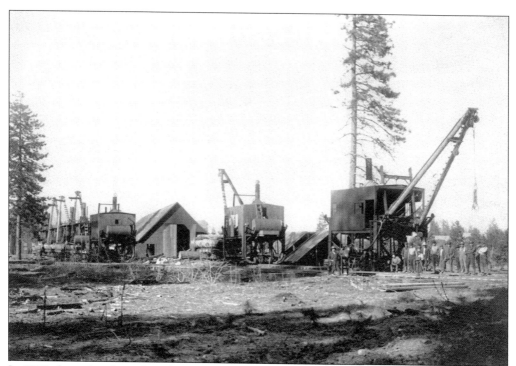

In 1907, the railroad purchased three new McGiffert log-loading machines from the Clyde Iron Works in Duluth, Minnesota. The McGiffert loader straddled the tracks when in use, with empty log flats passing under it. The above photograph by Charles R. Miller shows the three loaders waiting next to the original railroad shop building for the next season to begin, while the photograph below shows one of these loaders at work in the woods. (Above, Heritage Junction Museum; below, Ray Piltz collection, courtesy of Travis Berryman.)

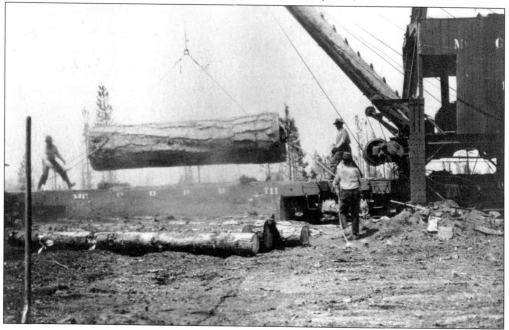

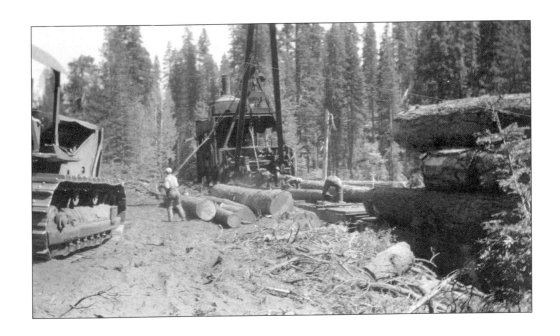

Two more photographs depict McGifferts at work in the woods. Early McGiffert loaders featured rigid booms; later models, such as those shown on these pages, featured booms that could swivel up to 15 degrees in each direction. Records indicate that the lumber company owned at least six McGiffert loaders. (Dennis Sullivan collection.)

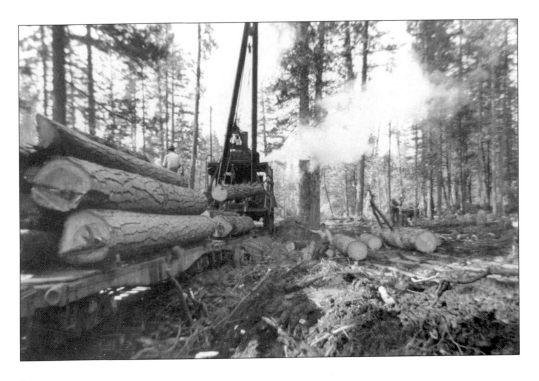

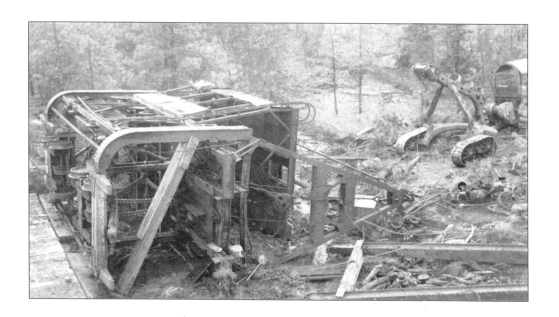

McGiffert loaders were very top-heavy machines and as such were prone to toppling over. The machine shown here had fallen on its side while in transit to a new landing. Note that the running gear has been lowered, which allowed the McGiffert loader to move under its own power, albeit slowly. When in use, the wheels would be folded up underneath the platform, with the bottom of the frame resting on the ties. (Dennis Sullivan collection.)

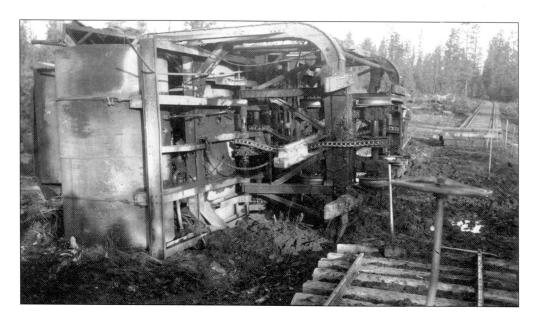

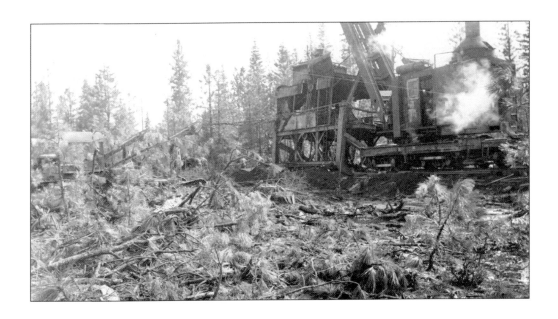

Help has arrived in the form of the big crane No. 8 and a tractor with a logging arch. Together the equipment has lifted the McGiffert back onto its feet. Its next trip will likely be to the Pondosa shop to get the damage repaired before it goes back to work in the woods. (Dennis Sullivan collection.)

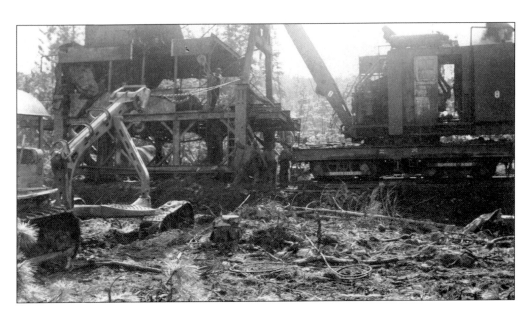

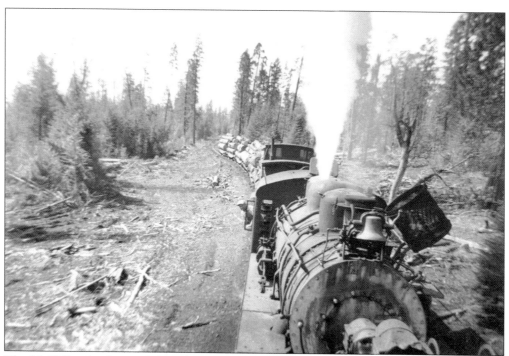

The McGiffert loaders and the other equipment used in the woods needed a steady supply of fuel, water, and empty cars to load. The lumber company filled these needs with log trains that operated from the major camps out to the loaders and then returned. The railroad supplied most of the locomotives and cars used on the logging railroads, with the lumber company supplying the crews and logging equipment. Two shots of a Pondosa-based log train rolling back to camp behind Nos. 21 and 23 are seen here. (Dennis Sullivan collection.)

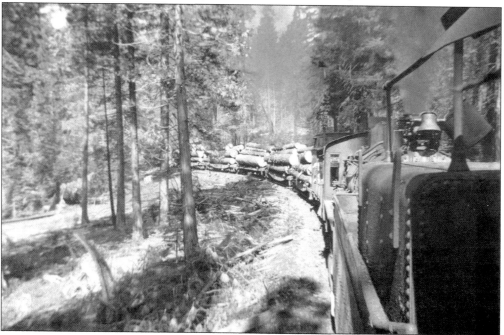

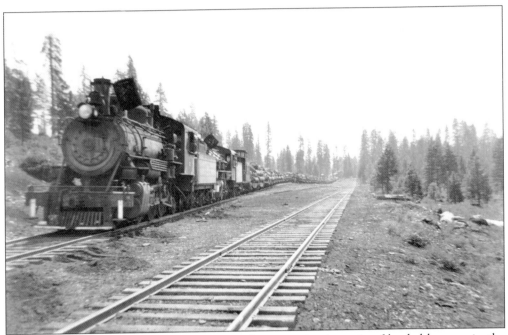

The train powered by Nos. 21 and 23 is seen here spotting its train of loaded log cars in the Pondosa Yards. (Dennis Sullivan collection.)

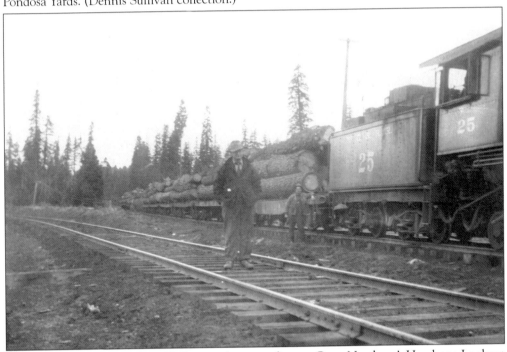

Logging superintendent Elmer Hall is seen here standing on Great Northern's Hambone-Lookout mainline while locomotive No. 25 waits patiently on Spur 529 for clearance to occupy the mainline with another load of logs bound for McCloud. Hall also supervised the construction of almost all of the railroad trackage built at the eastern end of the McCloud operations. (Dennis Sullivan collection.)

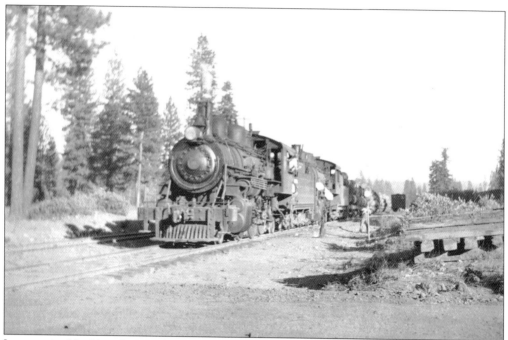

Locomotive No. 21 and a sister have paused for a moment in Bartle while in charge of a westbound log train. (A. Parsons photograph, courtesy of Travis Berryman.)

A locomotive has delivered loaded logs to the mainline connection and is in the process of shoving a new set of empty cars back to the loader. This view was taken from the cab roof. (Dennis Sullivan collection.)

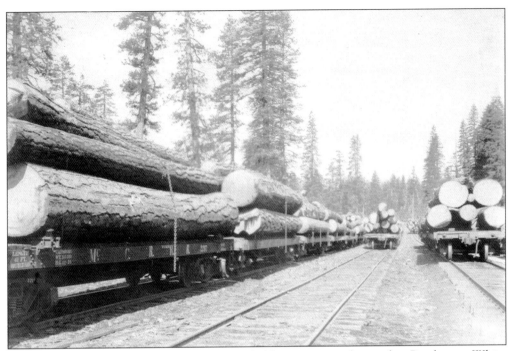

The lumber company would assemble the loaded log cars in yards at either Pondosa or White Horse, as seen in the photograph above. The McCloud River Railroad typically ran two trains a day east of McCloud, one to Pondosa and the other to Lookout Junction. These trains would bring empty log cars out to be exchanged for the loaded log cars left by the lumber company. The photograph below shows the No. 14 switching in Pondosa; the first cars behind the locomotive are a McCloud River boxcar carrying company supplies and two cars loaded with new ties. (Above, Heritage Junction Museum; below, Ray Piltz collection, courtesy of Travis Berryman.)

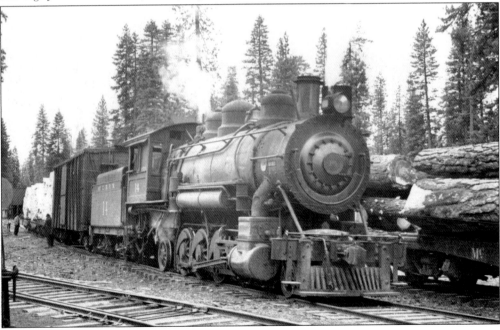

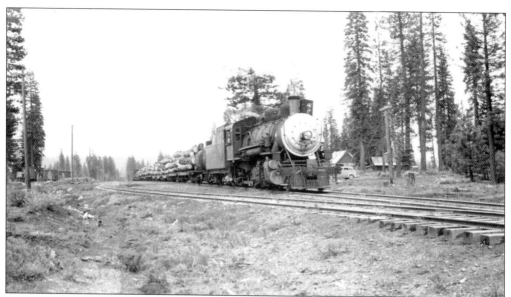

This photograph depicts the No. 26 leading a westbound log train through Bartle. (Jerry Lamper collection.)

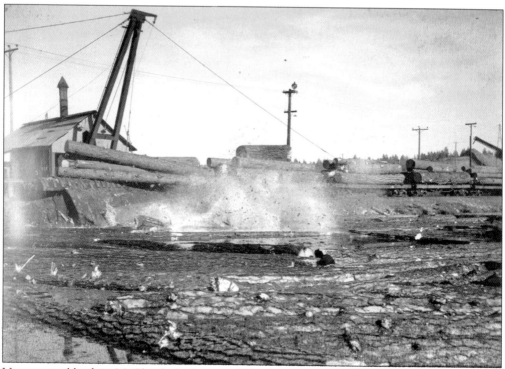

Upon arrival back in McCloud, the logs would be dumped into the log pond, where they would wait their turn to be sawed into lumber. This photograph shows the unloading process at the log pond. (Heritage Junction Museum.)

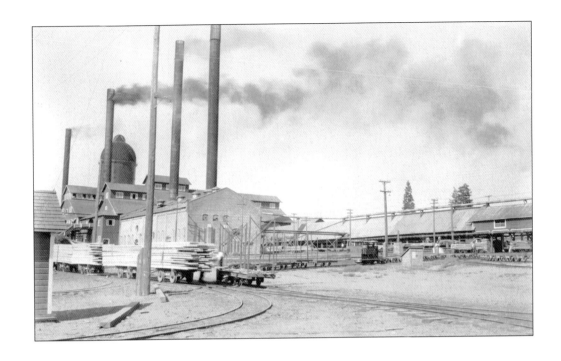

The lumber company maintained a large narrow-gauge in-plant switching railroad to move lumber throughout the sawmill complex. The switching railroad utilized horses and a handful of gas-mechanical and electric battery–driven locomotives, primarily Plymouth or General Electric products, to pull the small four-wheel flats used to carry the lumber. These pictures also show the increasing size and complexity of the McCloud sawmill complex, especially when compared to its rudimentary beginnings shown on page 15. (Heritage Junction Museum.)

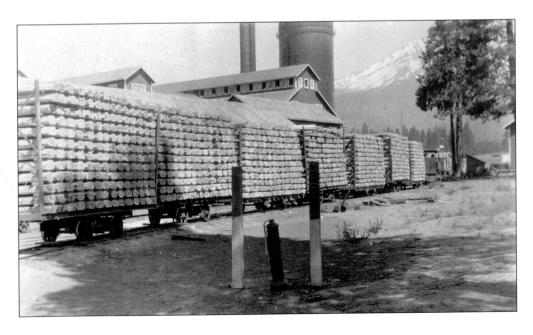

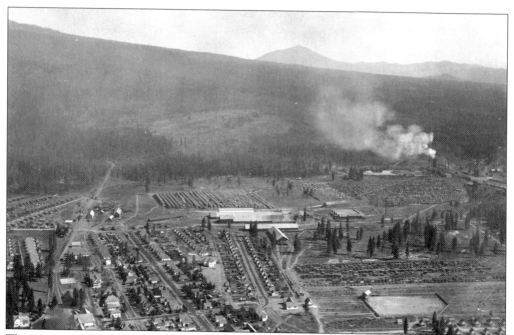

This is an aerial view of McCloud. The railroad's yards and shops are to the left; the sawmill is in the upper right corner; the planning mill and box factory fill the middle; and the town of McCloud fills the bottom part of the screen. The original sawmill site lies out of the picture below the lower left corner. (Heritage Junction Museum.)

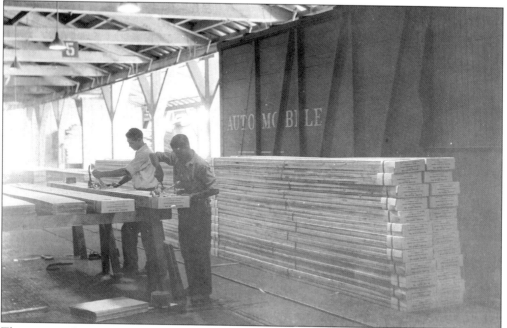

The process of turning a log into lumber in the massive McCloud complex would easily fill another book; the end process is shown here. Two employees are attaching protective covering, marked with the McCloud Shevlin Pine name, over the board ends to protect them during shipping. (Heritage Junction Museum.)

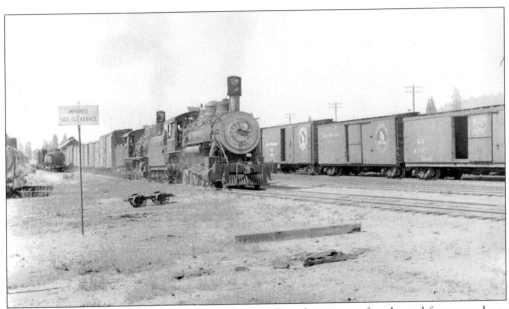

Locomotives Nos. 15 and 24 have finished assembling their train of outbound forest products and are leaving the McCloud yard for either Lookout Junction or Mount Shasta City. (Ray Piltz collection, courtesy of Travis Berryman.)

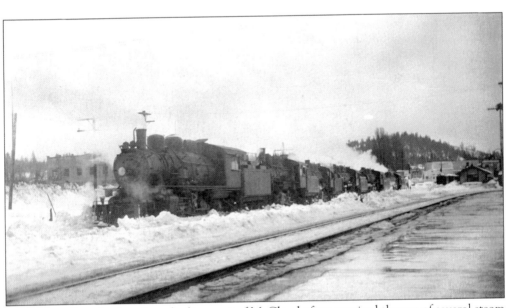

The long stiff grades found on the line west of McCloud often required the use of several steam locomotives, especially in snowy conditions. This day finds locomotives Nos. 24, 20, 15, 19, and 18 switching in the Mount Shasta City yards on a snowy day. The McCloud companies have finished their jobs, and the Southern Pacific will deliver the carloads of McCloud lumber to retailers. (Ray Piltz photograph, courtesy of Travis Berryman.)

Four

PIT RIVER RAILROAD

A railroad surveyor by the name of J. R. Scupham first recognized the Pit River's potential for generating hydroelectric power in 1875. However, the economics of developing the resource so far from any major population base did not pencil out until California's explosive population growth following the conclusion of World War I. Utility giant Pacific Gas and Electric (PG&E) started securing properties and water rights around 1917, and by 1919 the company had plans on the table for six power plants along the river.

PG&E recognized early on that transportation provided the biggest logistical challenge to the proposed projects. The nearest railhead lay on the McCloud River Railroad at Bartle, and through the winter of 1920–1921 the utility and the railroad jointly surveyed a rail line running from that point to the project area. Railroad construction started as soon as the snows melted enough to allow it, with the line completed to the first powerhouse by mid-September 1921. The next several years saw the railroad play a major role in hauling all supplies and materials needed to build three powerhouses, two large dams, and many miles of pipe. PG&E contracted operation of the railroad out to the McCloud River Railroad until 1924, when the utility took over the railroad for itself. In addition to the dam-building traffic, the railroad also handled some lumber and diatomaceous earth from the Cayton Valley area.

PG&E's completion of the Pit River projects by 1929 ended the need for the railroad. Crews removed the rails in short order, with the ties, spikes, and other fastenings left scattered along the grade. A few years later, the McCloud River Lumber Company reused portions of the old grade for its logging railroad system, with part of the grade later incorporated into the McCloud River Railroad's Burney extension. The hydroelectric projects made possible by the railroad are still a major part of the landscape today.

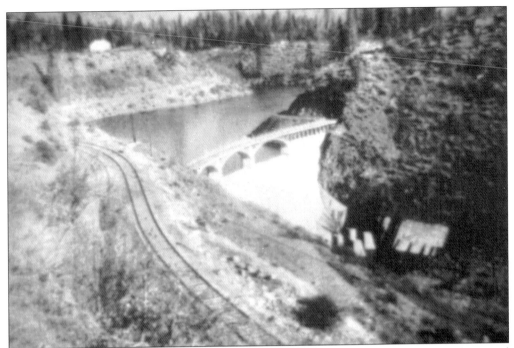

One of the more impressive structures built by the project was the Pit No. 3 Dam, which created Lake Britton. The dam is seen here shortly after its completion. Note the tracks of the Pit River Railroad in the foreground. (Henry Williams photograph, Thelma Shiplet collection.)

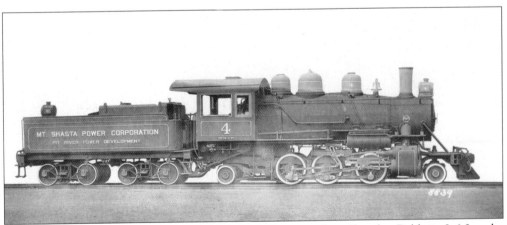

In 1924, PG&E purchased two new locomotives to operate the railroad, a Baldwin 2-6-2 and a three-truck Shay. The Baldwin, assigned or designated No. 4, is seen here posed for its builder's photograph prior to leaving the Eddystone, Pennsylvania, factory where it was built. (Jerry Lamper collection.)

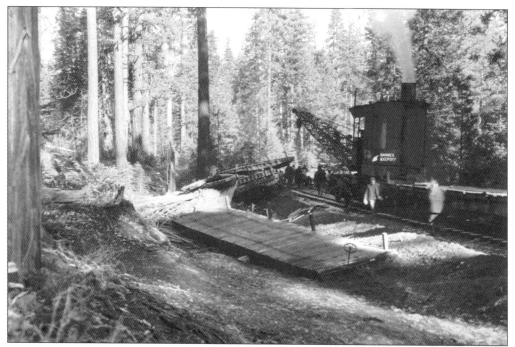

The Pit River Railroad had its share of mishaps. Here several carloads of structural steel have derailed in the Dead Horse Summit area, and one of the lumber company's Brownhoist locomotive cranes has arrived to help clean up the mess. (Heritage Junction Museum.)

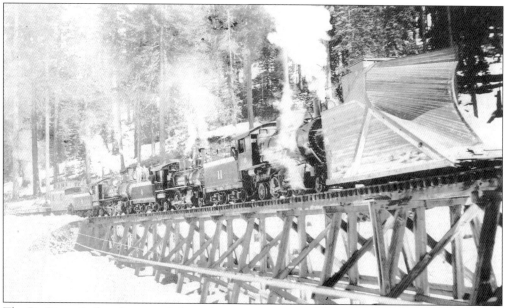

The Pit River Railroad operated through some major snowfall zones, which required the utility to periodically borrow snowplows from the McCloud River Railroad. This plow train is believed to be on the trestle that carried the railroad over Bear Creek. (Heritage Junction Museum.)

The removal of the railroad in 1929 left only a scar across the landscape and many assorted piles of junk to mark where the railroad once ran. Almost eight decades after the railroad disappeared, traces of it can still be found, such as the remains of a small trestle near Clark Creek (above) and some cut-and-fill work along the north side of Lake Britton near the Forest Service Dusty Camp recreational area (below). (Jeff Moore photographs.)

Five

MODERNIZATION

The first application of internal-combustion locomotives came in the form of a handful of small switchers purchased by the lumber company in the mid-1920s, with two of them going into service in the woods and the rest working on the narrow-gauge switching railroad in the McCloud sawmill. In 1948, Baldwin delivered the first diesel electric locomotive to the railroad, with three more between 1950 and 1951, essentially ending the use of steam on the mainline. The lumber company continued to use steam locomotives in its logging railroad operations until 1956, when a new General Electric diesel and the widespread use of log trucks finally put steam to bed.

In 1954, the lumber company secured the harvesting rights to 80,000 acres of prime timber in the Burney Basin. One of the stipulations in the contract called for the lumber company to complete a common carrier railroad to Burney, which led to the construction of the McCloud River Railroad's Burney branch. The new line used existing lumber company trackage from Bear Flat to Ditch Creek, with new construction beyond that point. The line opened in early July 1955 and provided direct rail service to a part of California that had waited a long time for it. The railroad soon hauled substantial amounts of lumber, as well as agricultural and mining traffic, to and from Burney in addition to the raw logs the line was built to haul.

U.S. Plywood purchased both McCloud companies in early 1964, with the use of rail to move logs and the closure of the Pondosa and Kinyon camps being two of the first casualties of the new ownership. Finished lumber shipments from sawmills in McCloud, Pondosa, and Burney remained strong enough to keep the railroad healthy. One steam locomotive, the No. 25, survived the end of steam, and it powered an active railfan excursion program between 1962 and 1975 that brought the railroad nationwide attention before rising insurance premiums and fuel prices forced the steam locomotive back into storage.

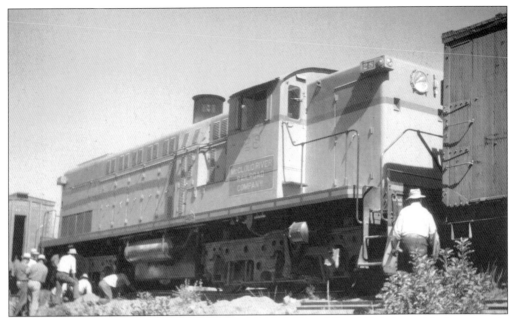

In 1948, Baldwin delivered this model DRS-6-6-1500 (Diesel Road Switcher with six axles, six traction motors, and 1,500 horsepower) to the McCloud River Railroad. The No. 28 initially spent a lot of time on the ties instead of the rail. Here officials and employees are looking over what appears to be a minor derailment shortly after the No. 28 arrived. (Heritage Junction Museum.)

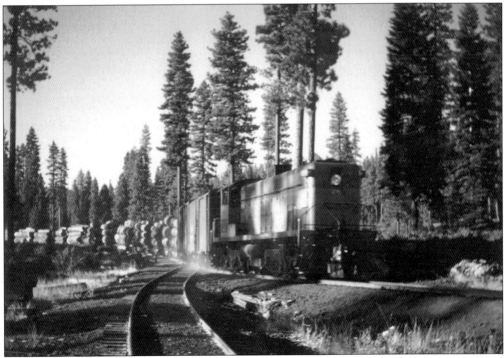

An accelerated track-maintenance program soon had the track structure in good enough shape to handle the heavy locomotive. The No. 28 is seen here leading a train of boxcars and log loads back toward McCloud. The location appears to be at Car A. (Travis Berryman collection.)

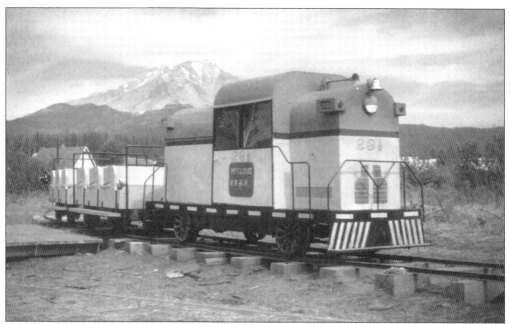

In 1955, the McCloud River Railroad built this little train for the McCloud Lumberjack Festival, an annual community event. The train consisted of one locomotive, No. 28½, and two passenger flats. The train gave rides around a circle of track during the event for a few years. (Heritage Junction Museum.)

In 1949, the railroad purchased a second new diesel from Baldwin. The No. 29 was nearly identical to the No. 28 except that it had dynamic brakes, a feature that improved the ability of the locomotive to keep train speeds down on steep grades. The No. 29 is seen here passing between the scale house and paint shop shortly after arriving. (Travis Berryman collection.)

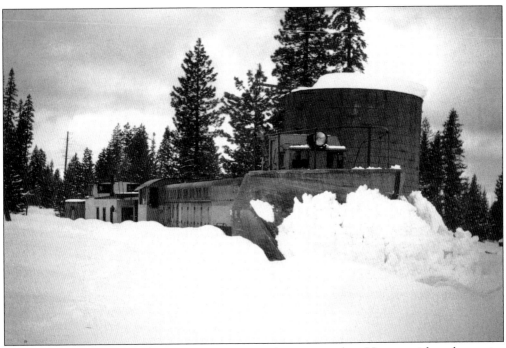

The No. 28 is seen here early in its career passing the water tank at Hooper with a plow train. (Travis Berryman collection.)

Shortly after the first diesels arrived, the railroad decided to adopt a logo. The final design, a bear balancing on a log with a fish in its mouth set in front of a profile of Mount Shasta, stemmed from a local school contest. The railroad made extensive use of the logo on locomotives, railcars, vehicles, buildings, and even trash cans. Jerry Lamper found this logo on fire car No. 1711. (Jerry Lamper photograph.)

In 1953, the railroad took delivery of two Baldwin diesel switchers, Nos. 30 and 31. The No. 28 is seen here leading one of the switchers and an endless string of empty log flats eastward through Bartle. (Ray Piltz photograph, courtesy of Travis Berryman.)

Another day finds the No. 31 leading the No. 28 and a log train through the woods, likely on the way to Pondosa. (John Monoff photograph, Ray Piltz collection, courtesy of Travis Berryman.)

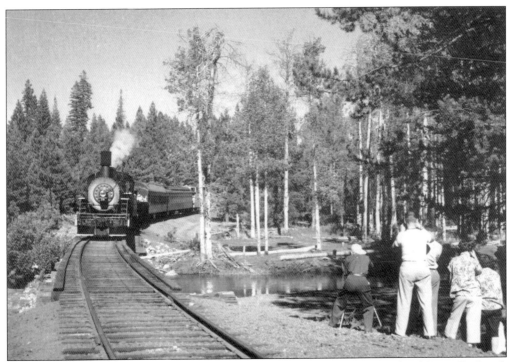

The late 1940s saw the first railfan excursion trains operate over the McCloud River Railroad. August 1952 finds the No. 18 in charge of a short excursion train at the Bear Creek Bridge on the Pondosa branch. (Ray Piltz collection, courtesy of Travis Berryman.)

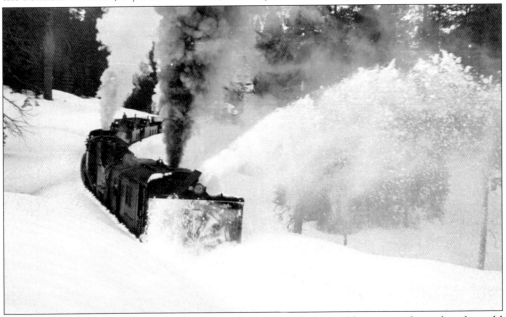

When snow accumulations surpassed what the bucker plows could remove, the railroad would borrow a rotary snowplow from the Southern Pacific to get the line open. In 1952, the SP rotary plows came east from McCloud for the first time, with the line over Dead Horse Summit plowed out. (Dennis Sullivan collection.)

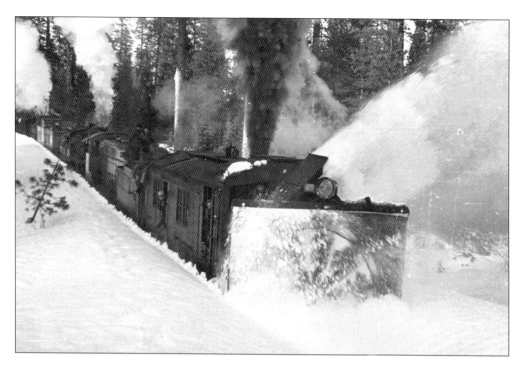

These are two more fine views of the SP rotary plow operating over Dead Horse Summit in 1952. A combination of steam and diesel power is being used to power the plow through the drifts. The railroad built the line from Bartle over Dead Horse Summit to Bear Flat in 1951, which allowed for the abandonment of the original Car A-Pondosa line. (Dennis Sullivan collection.)

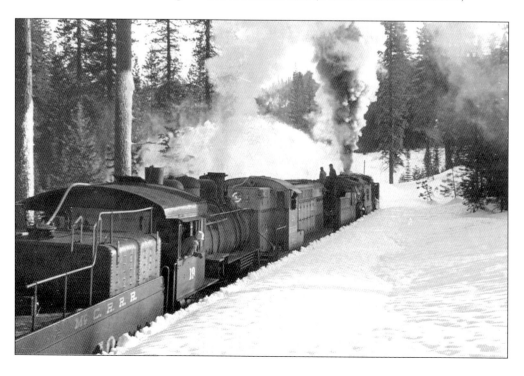

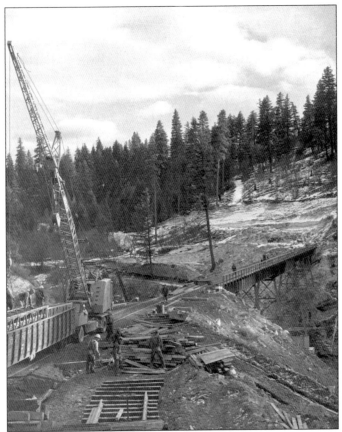

In 1954, the lumber company purchased the harvesting rights to 80,000 acres of pine timber centered south of Burney. The sale contract called for the lumber company to build a common carrier railroad to Burney, and to fulfill that requirement the lumber company financed the extension of the McCloud River Railroad from Bear Flat to Burney. The photograph at left shows the impressive bridge over Lake Britton nearing completion, while the one below depicts new track construction somewhere near Cayton Valley. (Above, Clyde Browning photograph, Travis Berryman collection; below, Heritage Junction Museum.)

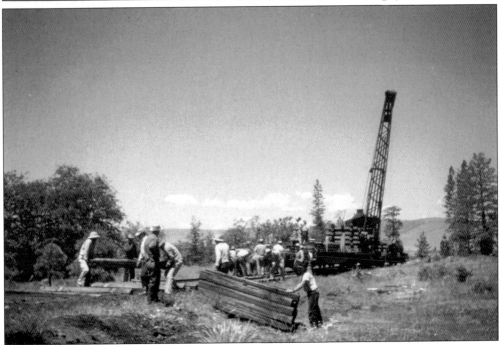

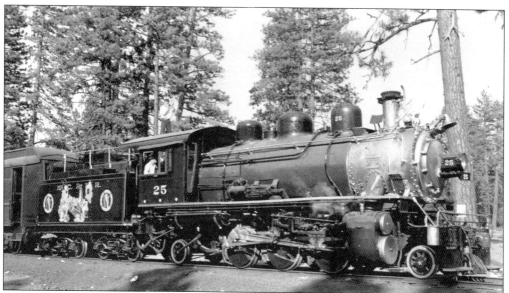

The new Burney extension officially opened in July 1955 with a grand celebration. The railroad pulled No. 25 from its woods service and gave it a new paint job, including a special mural designed by local schoolchildren on the tender. This photograph shows the locomotive leading a special passenger excursion into Burney during the event. (Stan Styles photograph, Jerry Lamper.)

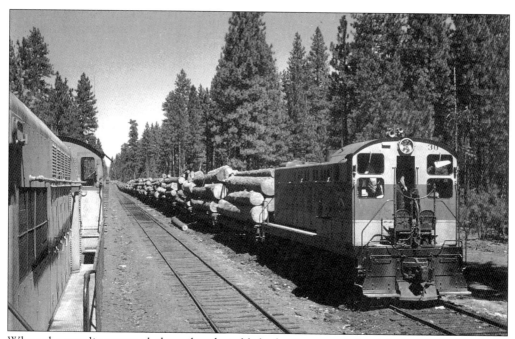

When the new line opened, the railroad established a Burney switcher job that worked both the sawmills in the Burney area and the lumber company log lines to the south of town. The switcher, powered by the No. 30, is seen here swapping cars with the daily road freight from McCloud at the three-track yard at Berry. The Burney switcher operated until 1964. (Ray Piltz photograph, courtesy of Travis Berryman.)

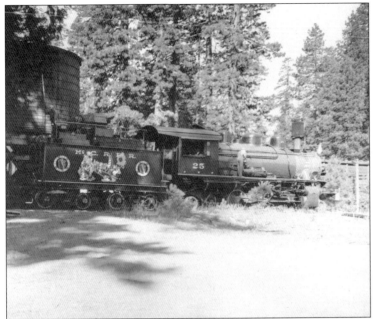

Following the festivities in Burney, the No. 25 went back to work in the woods. The locomotive is seen here getting serviced at the Pondosa water tanks between runs. (Dennis Sullivan collection.)

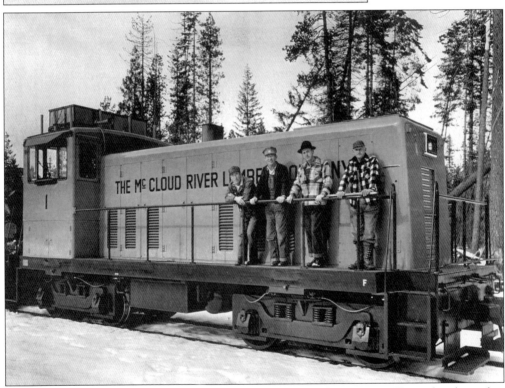

In August 1955, the lumber company purchased this new 600-horsepower, 70-ton diesel switcher from General Electric. The diesel is seen here with its crew on Spur 50 near Kinyon. The crewmen from left to right are Elmo Bevley, fireman; Bob Hogue, engineer; Ruel Methvin, conductor; and ? Fillmore, brakeman. The No. 1 operated out of Kinyon until 1961. The locomotive survives today as Modesto and Empire Traction No. 608 in Modesto, California. (Heritage Junction Museum.)

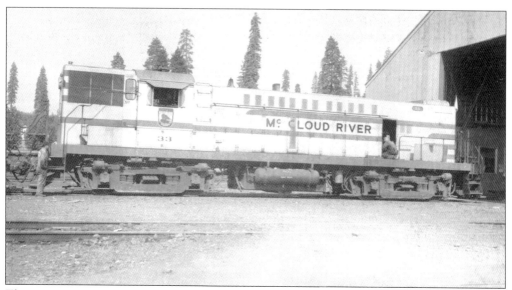

The increase in operations and traffic created by the Burney line resulted in a need for more motive power. In April 1955, Baldwin delivered two new model RS-12 locomotives to the railroad that became Nos. 32 and 33. The No. 33 is seen here getting some mechanical attention at the McCloud shop building on the last day of August 1957. (Jerry Lamper photograph.)

Steam locomotives finally saw their last use on the McCloud railroads by 1956. The No. 29 is seen here starting four of the McCloud steam locomotives on the first leg of their journey to the scrap yards in South San Francisco. (Heritage Junction Museum.)

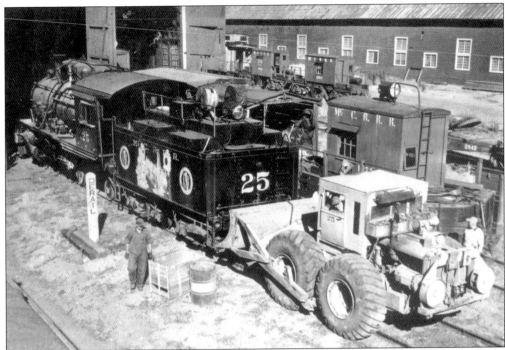

By 1957, the No. 25 remained as the only steam locomotive in McCloud. The railroad's tournadozer No. 25 is seen here switching steam locomotive No. 25 at the old paint shop building. Note flangers Nos. 1703 and 1773 and bucker/flanger No. 1775 are also visible in the photograph. (Ray Piltz collection, courtesy of Travis Berryman.)

Locomotive No. 30 demonstrates one of the hazards of turntable pits. The new steel shop building being constructed in the background would soon allow the railroad to tear down the roundhouse and eliminate the turntable pit. (Ray Piltz photograph, courtesy of Travis Berryman.)

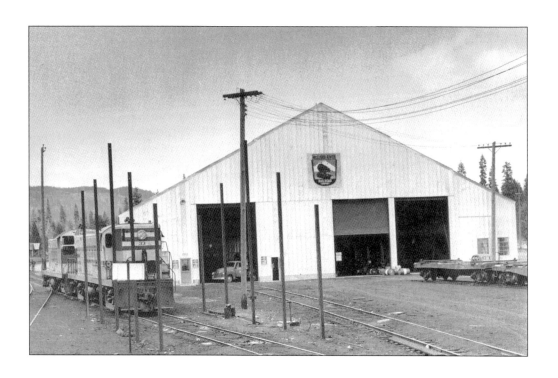

In 1957, the railroad completed the new steel shop building. The above photograph shows the shop building along with the first supports of what would become the sand tower. The image below depicts diesels Nos. 31, 29, 33, and 28 posed on the shop leads. (Above, Travis Berryman collection; below, Jerry Lamper photograph.)

Immediately after opening the Burney line, the railroad built a 7-mile-long branch line from Berry to the Scott Lumber Company mill west of town. This photograph shows locomotives Nos. 32 and 33 about to cross the Burney Creek bridge on the branch at Berry. (Joe Bispo photograph.)

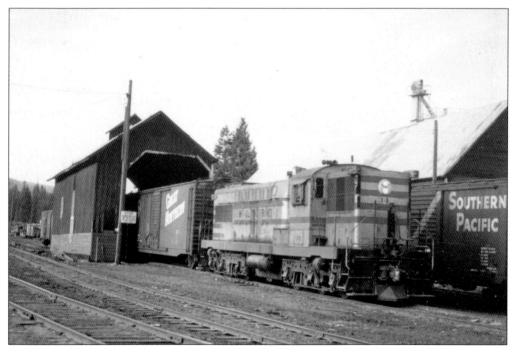

In 1963, the railroad sold locomotive No. 30 and replaced it with the No. 34, a Baldwin model AS-616 purchased from Southern Pacific. The No. 34 is seen here weighing cars at the scale house. (Joe Bispo photograph.)

After log hauling ended in 1963, the Scott mill became the principle shipper in Burney. By mid-April 1969, Publishers Forest Products operated the mill. One of the RS-12s and the No. 31 are seen here switching the mill. (Joe Bispo photograph.)

In 1960, PG&E built a natural-gas pipeline through the Burney area. The McCloud River Railroad moved over 1,000 carloads of pipe into Burney for this project. A quartet of Baldwin diesels are seen here moving carloads of pipe out of McCloud. (Heritage Junction Museum.)

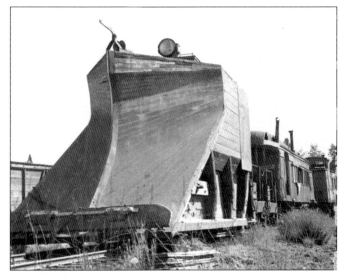

The reduction in operations following the closure of the log lines made some of the equipment surplus. In 1964, the railroad donated plow No. 1701, bucker/flanger No. 1787, coach No. 01, flanger No. 1773, and caboose No. 031 to a proposed railroad museum near Dunsmuir. The equipment is seen here gathered in the McCloud yard waiting shipment. All of this equipment, save for the No. 1787, survive today in the Railroad Park Resort. (Heritage Junction Museum.)

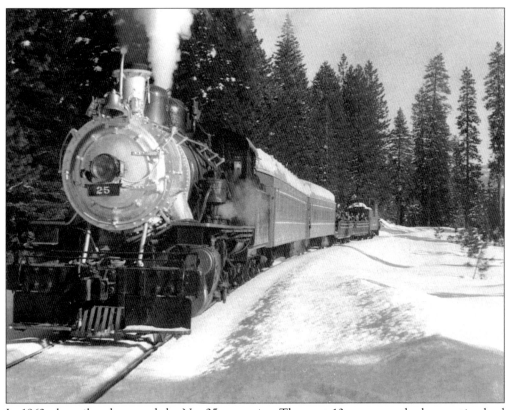

In 1962, the railroad restored the No. 25 to service. The next 13 years saw the locomotive lead an active passenger excursion program over the railroad. The locomotive is seen here leading the railroad's excursion train, which consisted of two ex–Southern Pacific "Harriman"-style coaches (Nos. 1015 and 1801) and two ex-Santa Fe flatcars (Nos. 501 and 502). One or more of the cabooses usually tagged along as well. (George Landrock collection.)

This photograph shows the No. 25 leading an excursion train toward Pondosa in the winter of 1970. (Dennis Sullivan photograph.)

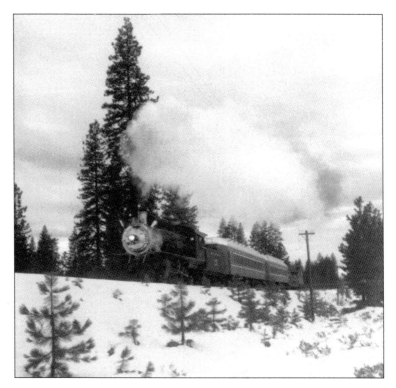

Veteran McCloud engineers Ray Piltz and Jack Jordan are seen here in the cab of the No. 25 on an excursion in April 1970. (Ray Piltz collection, courtesy of Travis Berryman.)

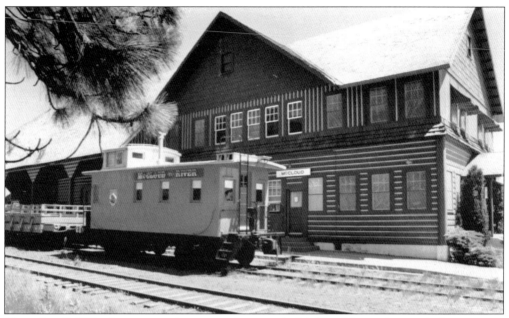

The railroad's VIP caboose is seen here spotted next to the McCloud depot along with the passenger flats. The caboose had been Great Northern No. X-548, with the McCloud River purchasing the car in November 1958. The car carried the No. 34 until the railroad rebuilt it for excursion service around 1965, giving it new No. 553 in the process. The car would survive on the railroad until sold to a private party in 2006. (George Landrock photograph.)

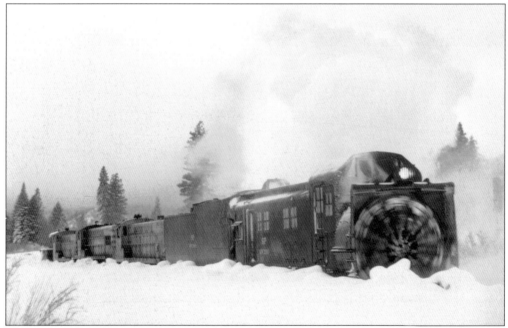

In March 1969, the railroad once again had to borrow a rotary snowplow from the Southern Pacific. Three Baldwin diesels are seen here pushing the plow up the hill from Mount Shasta City. The plow would spend that night opening the line to Pondosa. (Ray Piltz collection, courtesy of Travis Berryman.)

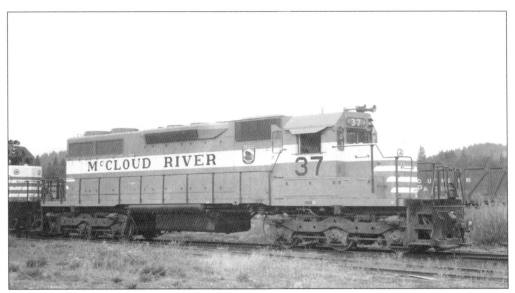

The late 1960s found the McCloud's fleet of Baldwin diesels nearly worn out. The railroad's search for replacement power resulted in the purchase of three new model SD38 diesels from the Electro-Motive Division of General Motors (EMD). The No. 37 is seen here in the McCloud yards shortly after arriving. (George Landrock collection.)

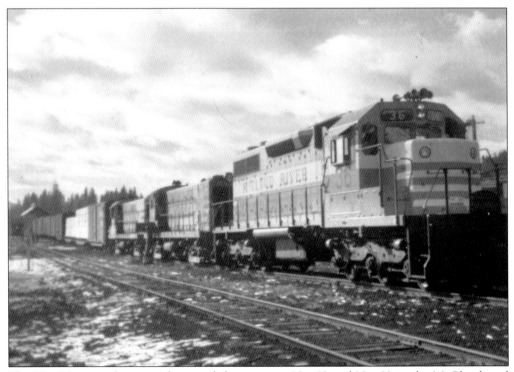

The No. 36 is seen here switching with locomotives No. 32 and No. 33 in the McCloud yard shortly after it arrived. The railroad retired and sold or scrapped the Baldwins shortly after the SD38s entered service. (Ray Piltz collection, courtesy of Travis Berryman.)

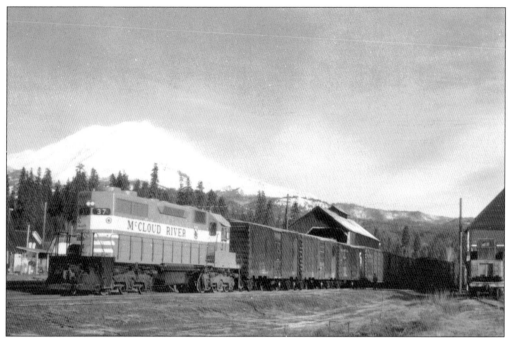

Ray Piltz is at the throttle of the No. 37 as it switches the McCloud yard on February 1, 1970. (Joe Bispo photograph.)

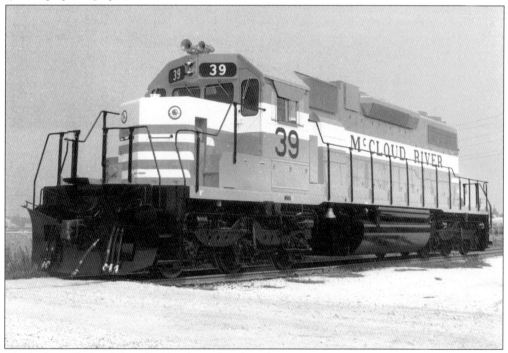

The high traffic levels handled by the railroad in the early 1970s saw the three diesels operating 24 hours a day, five days a week. This schedule left no time for shopping or breakdowns, which prompted the railroad to purchase a model SD38-2 diesel from EMD in 1974. The No. 39 is featured here in its builder's photograph. (Travis Berryman collection.)

Six

THE BOXCAR YEARS

The late 1970s saw a nationwide shortage of serviceable boxcars. The federal government approved higher per diem payments to railroads investing in new boxcars to end the shortage. This action led to a boxcar boom, during which thousands of new boxcars financed by investment firms and leased primarily to short line railroads appeared on the nation's rail network. Itel Rail was one of these firms, and in early 1977 it purchased the McCloud River Railroad, both as a source of loads and as a home shop for Itel boxcars. One of Itel's first acts was to provide the McCloud River with 400 of its own boxcars.

Unfortunately, Itel's timing could not have been worse. A series of sawmill closures between 1978 and 1979 reduced the McCloud's customer base down to one sawmill in the Burney Basin, although the situation did improve somewhat when California lumber giant Sierra Pacific Industries purchased and reopened the old Scott mill in Burney. The end of the incentive per diem program further compounded Itel's problems, as it suddenly had to find a home for thousands of returned boxcars. The McCloud River's equipment roster swelled as Itel sent many of these cars to McCloud for storage.

The railroad survived the dark times of the early 1980s only through Itel's willingness to cover operational losses and a $1.26 million federal track rehabilitation grant. Additional revenues came from leasing locomotives out to other railroads. Things began to turn around in the mid-1980s when two new shippers located on the railroad, a mining firm that shipped carloads of diatomaceous earth from a reload established at Cayton and a warehouse in McCloud that received carloads of paper destined for a printer in Reno. The railroad once again returned the No. 25 to service in 1982, which started another round of passenger excursions that lasted until 1986. The highlight of this steam resurgence came in the summer of 1985 when the No. 25 played a starring role in the movie *Stand by Me*.

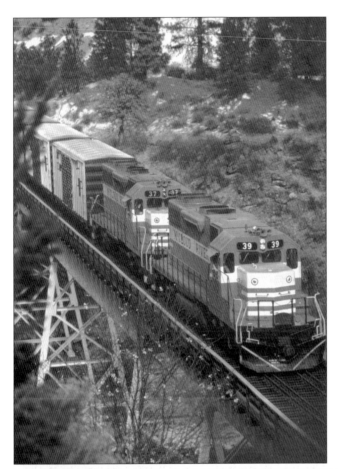

Shortly after the new boxcars started arriving, Itel hired a photographer to capture the cars on the line. Locomotives Nos. 39 and 37 are seen here leading the boxcars across the Lake Britton Bridge and again at another spot on the Burney Line. (Itel photographs, Travis Berryman collection.)

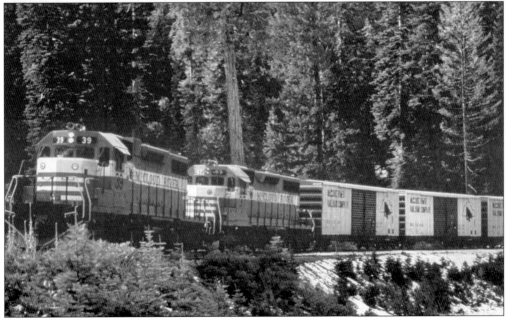

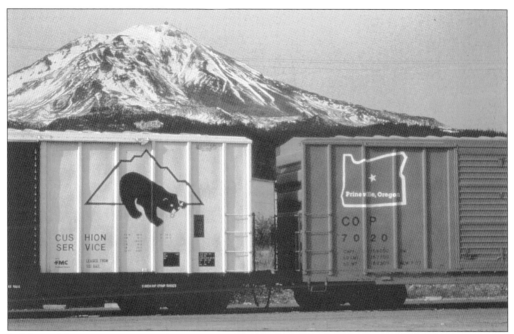

Itel leased boxcars to many other western short-line railroads in addition to the McCloud, and the McCloud shop became the home base for most of these cars. Two Itel boxcars, one leased to the McCloud River and the other leased to Oregon's City of Prineville Railroad, are seen here sharing a yard track in the McCloud sawmill. (Itel photograph, Travis Berryman collection.)

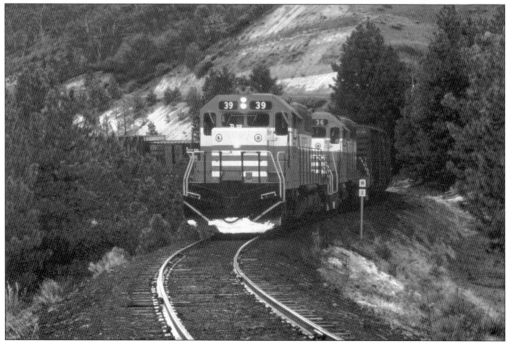

A cloudy day in November 1977 finds Nos. 39 and 36 leading a Burney-bound freight on the final approach to the Lake Britton Bridge. (Itel photograph, Travis Berryman collection.)

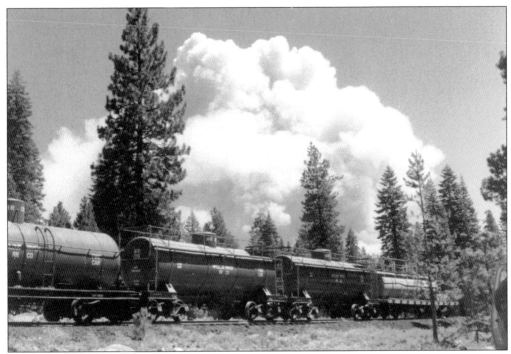

The summer of 1977 was a bad one for fires, with one blaze threatening Pondosa and another one burning over several miles of the Lookout Line near Camp Two. Firefighters called in the railroad's fire train to help with suppression efforts. The train is seen here near Pondosa with the smoke plume from that fire visible in the background. (Sid Muma collection, courtesy of Travis Berryman.)

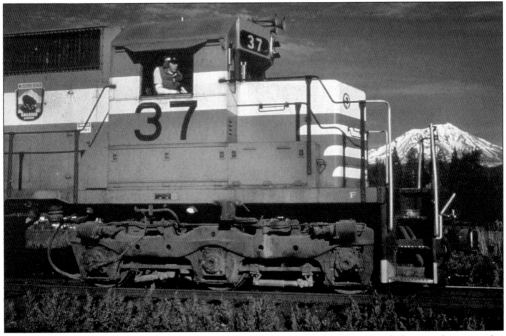

A young George Landrock is seen here at the controls of the No. 37 while switching in the McCloud yard in March 1977. (Itel photograph, Travis Berryman collection.)

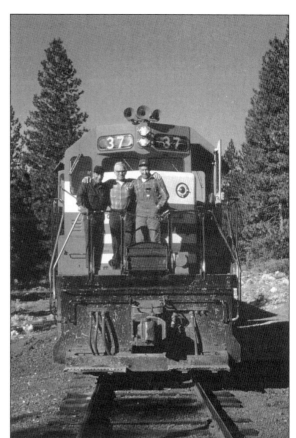

Two photographs of typical McCloud operations around the time of the Itel takeover can be seen on this page. The image at right shows engineer Ray Piltz flanked by fellow employees Carol Julien (left) and Fred Roberts (right) on the No. 37; this is very likely a Lookout job. The photograph below is of the No. 36 pushing one of the 1938-built bucker/flangers eastward out of McCloud. (Mike Devlin photographs, courtesy of Travis Berryman.)

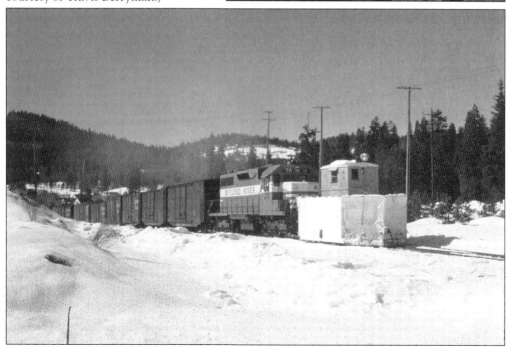

George Landrock's employment with the railroad led to many fine photographs, including this one of the No. 38 leading a train through a snowy landscape above Cayton. (George Landrock photograph.)

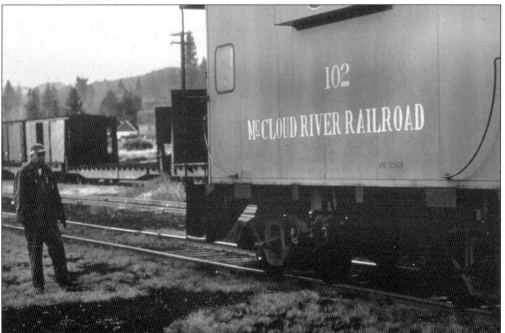

One of the veteran shop employees on the railroad was Jim Berryman. Jim is seen here next to caboose No. 102, one of two new steel cabooses acquired in February 1962. (Travis Berryman collection.)

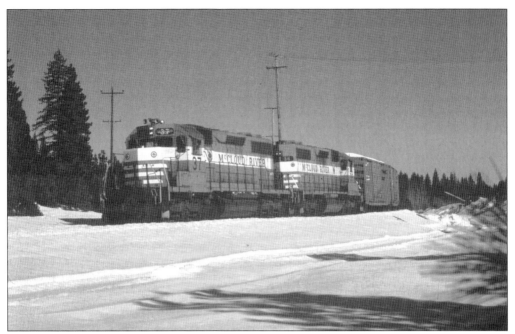

A cold morning in February 1982 finds Nos. 37 and 36 switching City of Prineville Railroad boxcars in the McCloud yard. (Louis Thelen photograph.)

McCloud engineer Ernie Nelson is at the controls of one of the locomotives on May 17, 1980. Ernie was one of the principle organizers of many of the railfan excursions operated over McCloud in the 1960s and 1970s, which led to his eventual employment with the company. (Louis Thelen photograph.)

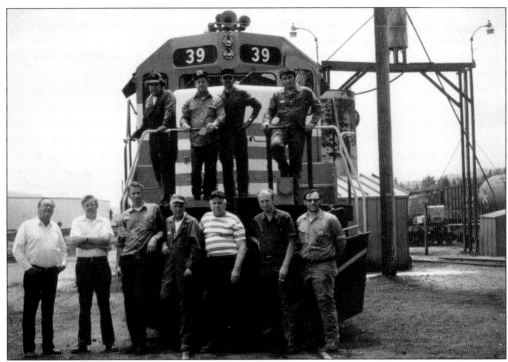

The McCloud shop crew has gathered around the front of the No. 39 for this group portrait in a manner similar to the above photograph on page 28. (Travis Berryman collection.)

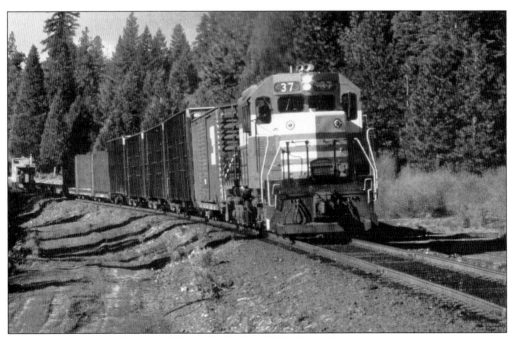

The morning of October 27, 1979, finds the No. 37 leading a Burney job eastward just past the Pilgrim Creek Road crossing. (Louis Thelen photograph.)

Shortly after Champion International closed the McCloud mill, a new owner, P&M Cedar Products, reopened part of the sprawling complex. P&M only occasionally shipped over the railroad. The cold morning of February 5, 1982, finds Nos. 36 and 37 switching a boxcar and a flatcar into the mill. (Louis Thelen photograph.)

The McCloud River Railroad spent a good amount of money and effort in the early 1980s unsuccessfully trying to develop new industry on properties the company owned in Burney and McCloud. This sign at Burney was part of that effort. The line of idled boxcars in the background speaks volumes about the health of the rail industry at this time. (Travis Berryman collection.)

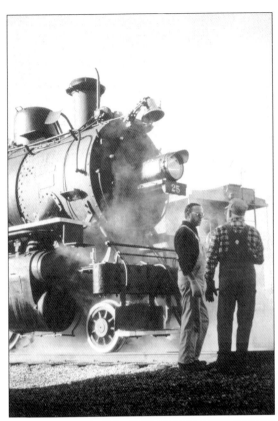

Steam locomotive No. 25 returned to service in 1982, which started another period of passenger excursions that lasted until 1986. Malen Johnson and Ray Piltz are seen here readying the old steamer for another day of hauling passengers over the railroad. (Ray Piltz collection, courtesy of Travis Berryman.)

In 1982, the railroad repainted locomotives Nos. 36, 37, and 38 into a new brown with orange stripes paint scheme meant to honor Auburn University, which was railroad president Bill Herndon's alma mater. The railroad decided to name the No. 36 after longtime employee and former president Sidney E. Muma. Sidney and his wife, Helen, are seen here with the No. 36 at the ceremony marking the event. (Travis Berryman collection.)

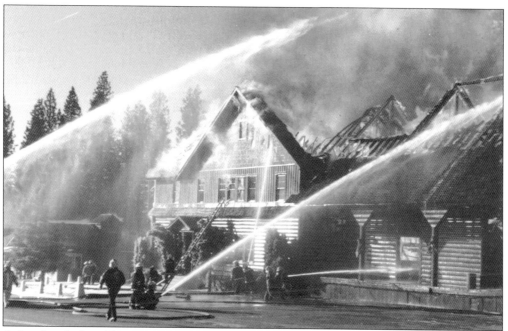

A few days before Christmas in 1990, the old McCloud depot and office building burned to the ground. The company lost many of its old records along with many priceless artifacts and pictures in the fire. These two pictures show the firefighting efforts and the ruined shell of the building after the flames died down. The railroad demolished the structure afterwards, leaving only the two-story brick vault. The railroad moved its headquarters into leased space. (Dennis Berryman photographs.)

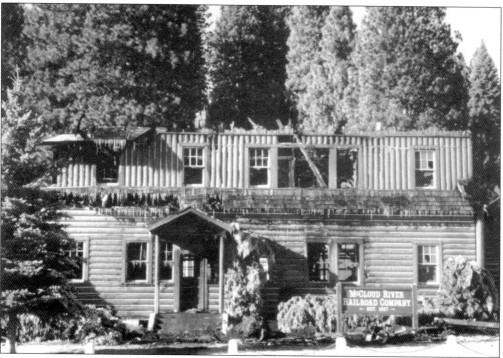

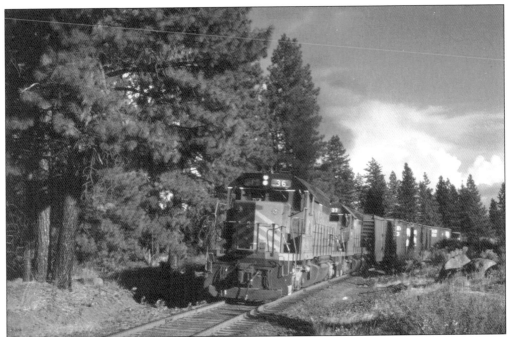

By the mid-1980s, inbound paper had replaced outbound lumber as the lifeblood of the McCloud River. The railroad hauled the paper from Lookout Junction to a warehouse in McCloud, where it would be reloaded into trucks for final delivery to printers near Reno. Several carloads of paper are seen here following Nos. 36 and 37 out of Lookout Junction in September 1991. (Sean Zwaggerman photograph.)

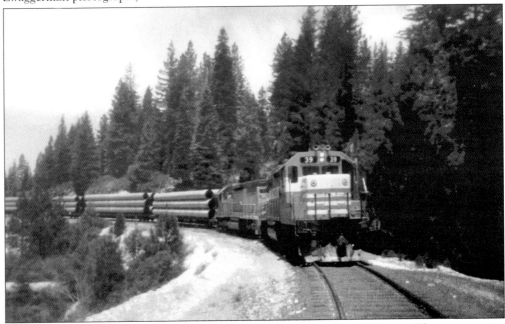

The spring of 1992 saw PG&E build a second natural-gas pipeline through Burney. This construction effort saw the railroad move approximately 350 carloads of pipe from Mount Shasta to Burney. Nos. 39 and 37 are seen here with a loaded pipe train on the Big Canyon fill. (Jeff Moore photograph.)

Seven

MCCLOUD
RAILWAY COMPANY

Itel Rail decided to exit the railroad business in late 1991. The for-sale sign placed on the McCloud River Railroad failed to draw any immediate serious interest, but Itel did sell most of the boxcars on the McCloud roster to a subsidiary of General Electric Capital. In March 1992, Itel announced that the railroad had been sold to Jeff Forbis and his family, ending several months of speculation that the railroad might be abandoned.

Jeff Forbis was the last president of the McCloud River Railroad. On July 1, 1992, he assumed ownership of the property, with operations to be handled by his new McCloud Railway Company. The McCloud Railway worked hard to increase the freight traffic base, which brought some agricultural traffic in the form of wheat and sugar beets shipped from the Burney Basin. The shop continued to handle outside contract repair work, with General Electric Capital's boxcars providing much of the business. Freight traffic increased to around 3,000 loads a year by 1996–1997, more than triple what the railroad had hauled a decade earlier.

However, the good times did not last. The realignment of the major western railroads, brought about by a series of mergers, cost the railroad the paper traffic, which reduced operations on the Lookout Line to one train a week or less. The dawn of the 21st century found the railroad with only two remaining steady shippers, the Sierra Pacific Industries sawmill in Burney and Dicalite Corporation at Cayton. Together the two shipped less than 1,500 loads a year, which was not enough to sustain continued operations. The Lookout Line went under first, with the last train to Lookout running in December 2003 and the rails removed east from Hambone in 2005. The McCloud Railway continued on, but a failing infrastructure, an annual operating loss averaging $500,000, and no prospects for increased business forced the company to end all operations east of McCloud in June 2006. The railroad received permission to abandon that line in October 2006. The railroad makes its final stand on the passenger business.

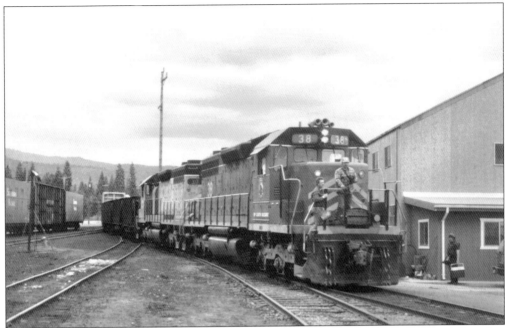

A cloudy afternoon in May 1994 finds roadmaster Glen Davis, conductor Michael Zetocha, and engineer Carol Julien arriving at the shop with a Lookout job. The ballast hoppers behind the locomotives have been picked up from the large ballast quarry at Porcupine. (Travis Berryman photograph.)

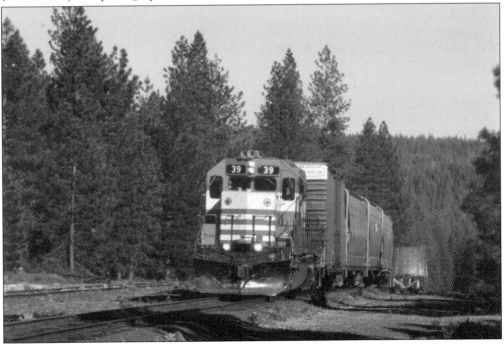

A single boxcar carrying paper for the warehouse in McCloud and three empty covered hoppers destined for the Dicalite Corporation reload at Cayton trail the No. 39 westward through Bartle on the return leg of a trip to Lookout. (Sean Zwaggerman photograph.)

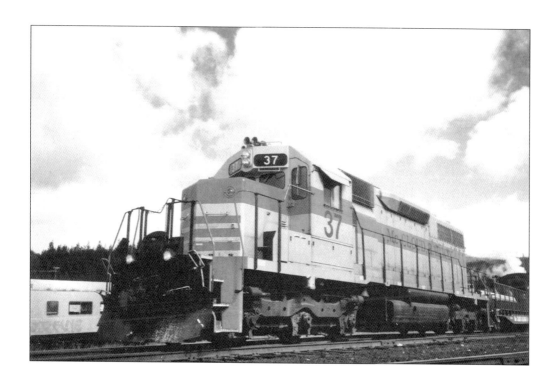

In the summer of 1996, the McCloud Railway repainted Nos. 36 and 37 into silver and red schemes based on the final colors worn by the Baldwins. The No. 37 (above) shows off the new paint during a railfan excursion in May 1998. Caboose No. 102, seen below at Lake Britton in November 2002, also got a new solid red with white lettering and trim paint job (below) to mark the new ownership. (Above, Alicia Moore photograph; below, Jeff Moore photograph.)

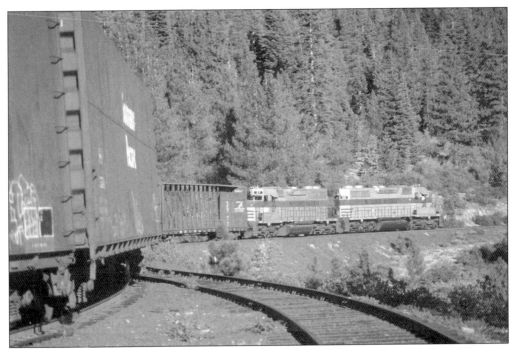

A Yard and Hill job is seen here on October 25, 1999, entering the switchback at Signal Butte on the return trip to McCloud with empties for the next day's Sierra job. Caboose No. 102 will lead the train on the rest of the journey down the hill to McCloud. (Travis Berryman photograph.)

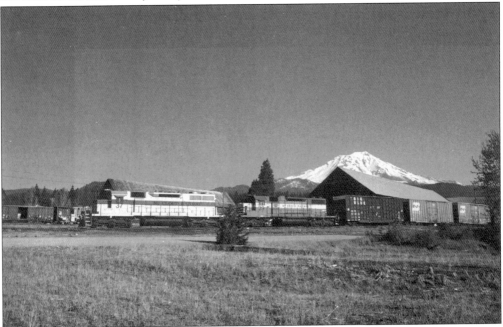

An early morning finds Nos. 37 and 39 switching the paper reload warehouse in McCloud. The date is May 1997, and the McCloud Railway's freight business is starting to slip. By mid-summer, the No. 39 would be sold off, and the paper traffic itself would disappear within a year. (Sean Zwaggerman photograph.)

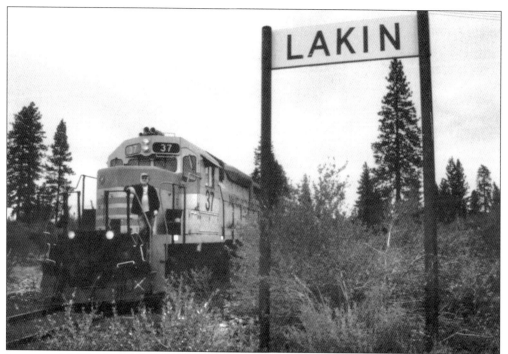

Longtime McCloud engineer Malen Johnson is seen here posing on the steps of the No. 37 at Lakin in August 2003. Lakin was undoubtedly one of the most desolate spots on the McCloud railroads. (Roger Titus photograph.)

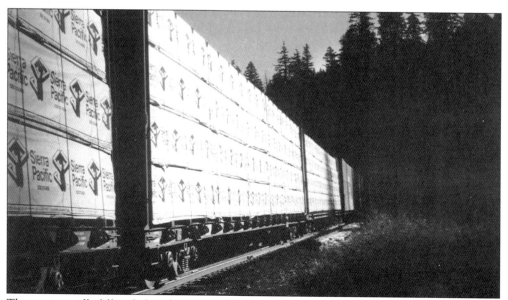

The sun is rapidly falling below the western horizon as carloads of wrapped lumber and wood chips from the Sierra Pacific mill trail two locomotives off of the Lake Britton Bridge. After caboose No. 102 clears the bridge, silence will once again fill the forest. (Jeff Moore photograph.)

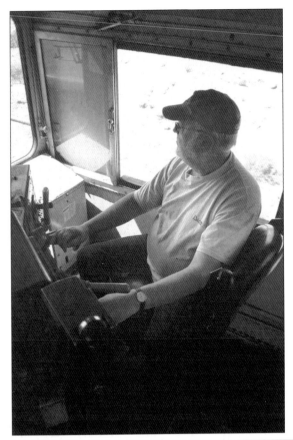

Engineer Malen Johnson wrapped up a 41-and-a-half-year career with the McCloud railroads at the end of August 2003. August 30 found Malen on his last trip in freight service to Burney, first at the controls of the No. 36 and then signing out with dispatcher Brenda Baldi at the end of the day. Malen's final trip came the next day with a Yard and Hill job to Mount Shasta City. (Travis Berryman photographs.)

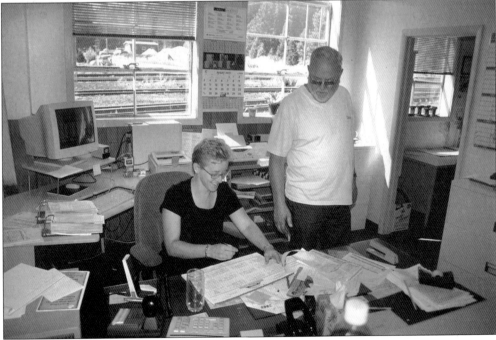

Near Obie, the railroad crossed Bear Creek on this impressive fill. The railroad lost the fill twice during storms in 1986 and 1996. No. 36 is seen here leading a Sierra job back toward McCloud. (Sean Zwaggerman photograph.)

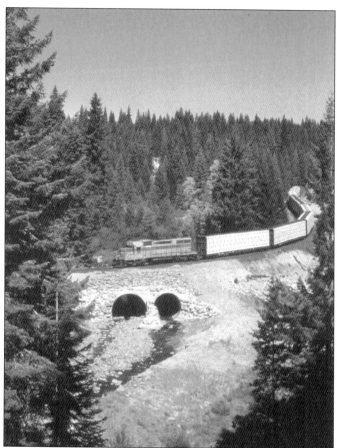

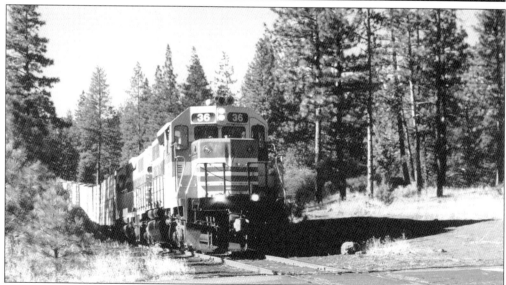

The shadows are starting to get tall as Nos. 36 and 37 lead 18 loads of lumber and wood chips across Burney Creek in November 2002. Engineer Malen Johnson is blowing the warning horn for the Black Ranch Road crossing. (Jeff Moore photograph.)

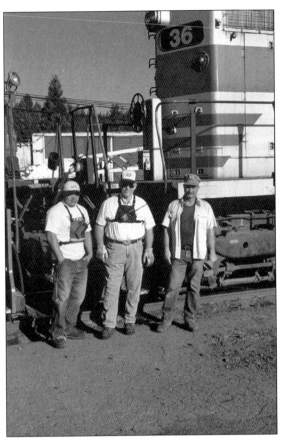

The morning of July 8, 2004, found engineer Michael Zetocha, brakemen Bob Sharrah, and Kenji Maumasi posed next to their power prior to working another day on the Yard and Hill job. (Travis Berryman photograph.)

One of the first moves for the train crew on this day was to weigh the lumber, wood chip, and diatomaceous earth loads brought from Burney the day before. Bob Sharrah is seen here in the scale house recording car weights. (Travis Berryman photograph.)

Bob Sharrah is seen here waving to the photographer as he throws a switch in the McCloud yard on July 6, 2004. (Travis Berryman photograph.)

The afternoon of October 25, 2004, found Kenji Maumasi grinding on the end of the centerbeam flatcar in the McCloud shop. (Travis Berryman photograph.)

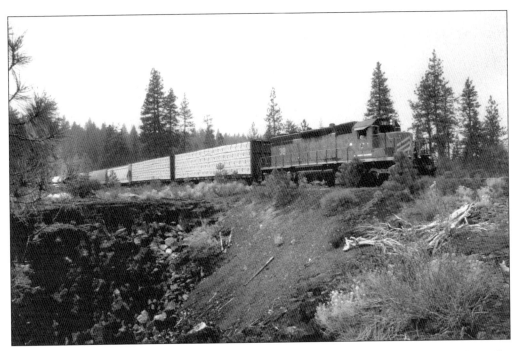

After the paper traffic vanished, operations to Lookout dropped to one train a week or less. The traffic did not warrant the continued operation or maintenance of the line, and in mid-December 2003, Burlington Northern Sante Fe, corporate successor to the Great Northern, closed the Hambone-Lookout trackage in favor of a haulage agreement with Union Pacific. The No. 38 is seen here a month before the end of operations, with an eastbound freight passing over a collapsed lava tube near Chippy Spur. (Roger Titus photographs.)

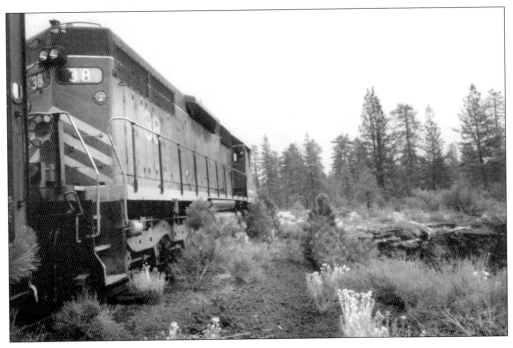

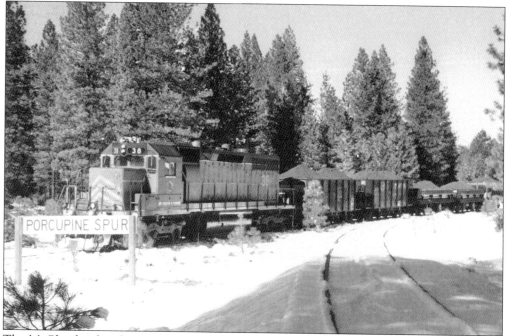

The McCloud railroads carried on operations east of Hambone for 73 years. All that came to an end on Sunday November 28, 2004, when the McCloud Railway ran a work extra as far as Porcupine for one last load of ballast materials. The No. 38 is seen here backing the last train on the Lookout Line out of the Porcupine Spur. (Roger Titus photograph.)

An A&K Railroad Materials scrap crew removed most of the Hambone-Lookout trackage in October 2005, leaving only a trail of cinders to mark where the trains once ran. This view is looking east through "Hell's Gate" and down the now-empty roadbed from the end of McCloud Railway ownership at Hambone. (Jeff Moore photograph.)

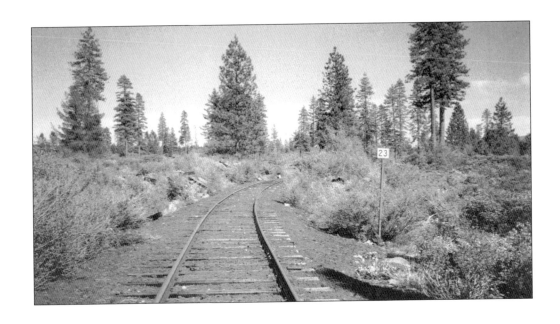

Here is a pair of comparison photographs of the Lookout Line with rails in June 2004 (above) and without rails in August 2006 (below). The location is Milepost BH-23, which is in the middle of the lava flows near Lakin. (Jeff Moore photographs.)

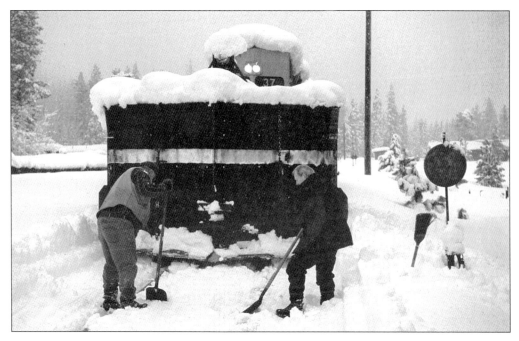

The winter of 2005–2006 proved to be another tough one in McCloud country. The morning of March 6, 2006, found the McCloud Railway digging out from yet another snowstorm. Seen above in the early morning are engineer Bob Sharrah and owner/president Jeff Forbis digging out a switch in the McCloud yards; later in the day the No. 37 and the railroad's Jordan spreader No. 1850 were plowing out the Mount Shasta Line at Pierce. The railroad purchased the Jordan in 1952 to supplement the wooden bucker plows. (Travis Berryman photographs.)

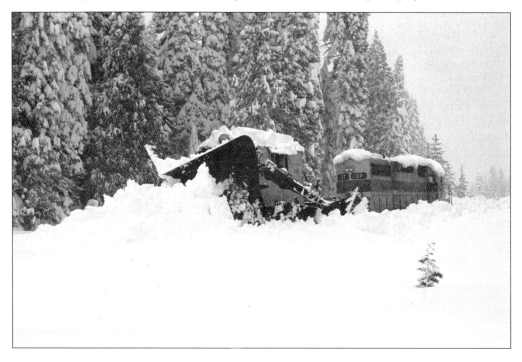

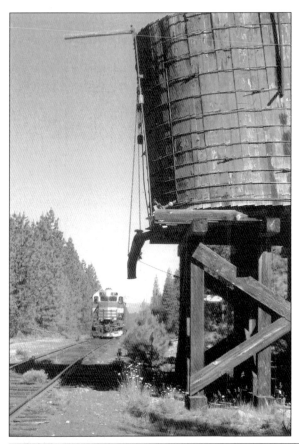

The McCloud Railway entered the summer of 2006 on borrowed time. Continued economic problems forced the railroad to seek abandonment of all trackage east of McCloud, with authority to do so received in October 2005. However, the quirks of the regulatory process delayed this authority, which forced the railroad to continue operations. In the meantime, Sierra Pacific Industries opened a reload for the Burney Mill on the Burlington Northern Santa Fe line at Nubieber, California, which substantially reduced freight traffic on the McCloud Railway. Scenes such as the No. 37 approaching the Bartle tank (left) and then switching at the Sierra Pacific Sawmill (below) became increasingly rarer events. (Jeff Moore photographs.)

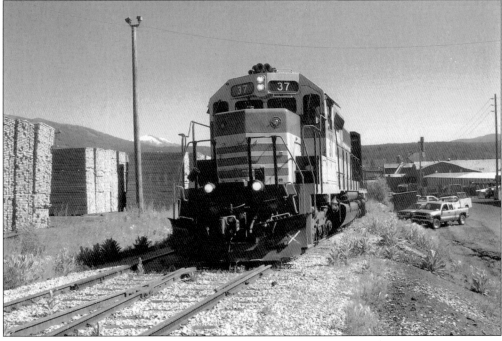

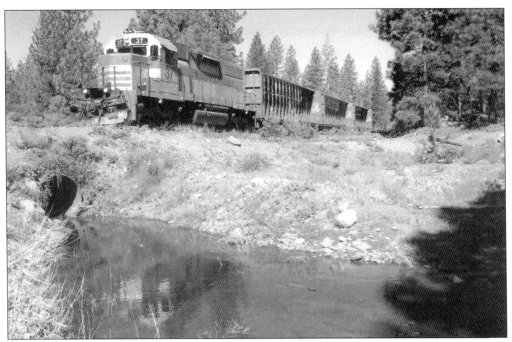

The railroad crossed an intermittent drainage at Bartle wye; the No. 37 casts a reflection in the pool created behind the railroad grade. The date is June 20, 2006, and this is the third to last revenue freight to Burney. (Jeff Moore photograph.)

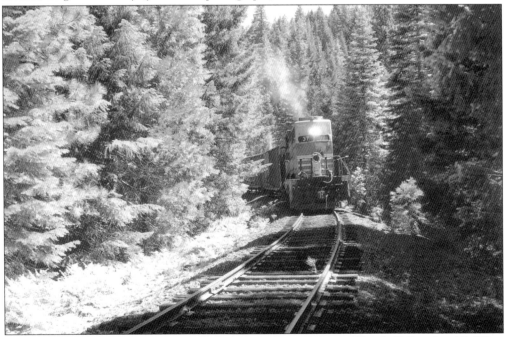

By the 1930s, the railroad had replaced the big trestle at the base of Bartle Hill with a fill. What could have turned out to be the final train movement across the trestle site saw the No. 37 bringing four empty boxcars down from Car A on June 20, 2006. This view is taken from approximately the same vantage point as the lower photograph on page 18. (Jeff Moore photograph.)

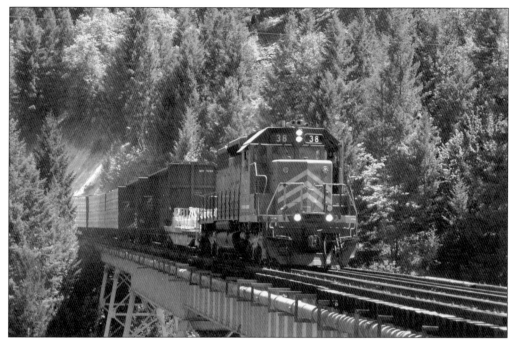

When the McCloud River Railroad built the Burney line in 1955, it announced that the Burney tract would provide enough timber to keep trains running for 50 years. As things turned out, the railroad beat that projection by one year. Sierra Pacific notified the railroad that it would not need its services any longer starting on July 1, 2006, and on June 29 and 30 the McCloud Railway ran its last revenue freight to Burney. The last train is seen here crossing the Lake Britton Bridge (above) and rolling into the setting sun at Bartle (below). The McCloud Railway would come to Burney one more time in mid-August to retrieve some bad-ordered cars from Berry. The days of McCloud locomotives moving lumber and mineral traffic up and down the mountains were over. (Drew Jacksich photographs.)

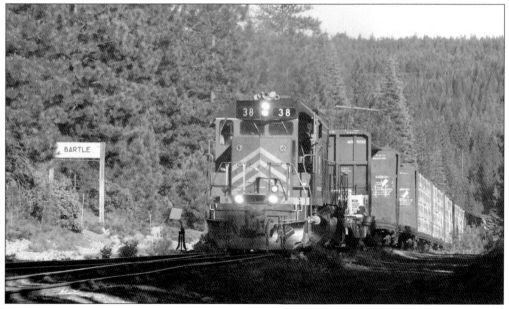

Eight

SHASTA SUNSET DINNER TRAIN

The McCloud Railway Company did not initially consider entering the tourist railroad business. However, the company would host excursions operated by others. The first such trip occurred in the spring of 1994 when Trains Unlimited Tours brought a former McCloud steam locomotive from the nearby Yreka Western Railroad for a full weekend of excursions. That special demonstrated the allure the McCloud still had, and by that fall the railroad had plans in place to enter the passenger business on its own.

The McCloud Railway started purchasing passenger cars in the spring of 1995. Seven heavyweight passenger coaches came from a failed tourist attraction in Iowa, with six additional coaches acquired from private sources. Three flatcars equipped to haul passengers and a couple of cabooses rounded out the fleet. The Forbis family set up the Shasta Sunset Dinner Train to handle the passenger business, with the dinner train going into service in the spring of 1996.

The McCloud Railway decided to return steam power to the road, and by late 1995 the company completed acquiring the No. 25 from a private party. The No. 25 reentered service in late 1997. In early 1998, the railroad purchased a second former McCloud River steam locomotive, the No. 18, from the Yreka Western Railroad. The No. 25 operated until February 2001, when the shop finished restoring the No. 18. The two steamers operated one trip together, after which the No. 25 went back into storage. The No. 18 operated many times over the next several years, but in the end the McCloud Railway could not make running steam a paying proposition. The railroad placed the No. 18 up for sale in late 2004, and a buyer in Nevada was quickly found. The No. 18 made its final trip on the McCloud in early August 2005, with the locomotive departing on two trucks in April 2007.

The Shasta Sunset Dinner Train continues to keep the rails west of McCloud shiny year-round, with a short excursion to Signal Butte added in the summer months. Some possibilities for future freight traffic exist, but until or unless they materialize the dinner train alone sustains the remaining railroad.

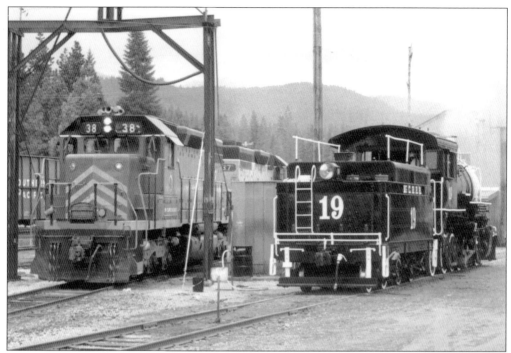

In the spring of 1994, Trains Unlimited Tours ended an eight-year drought of passenger operations on the McCloud railroads. A cool morning in late April finds Yreka Western's ex-McCloud River No. 19 steaming in front of the McCloud shop building, seen above. Saturday April 30, 1994, would see the No. 19 lead a passenger excursion to Burney and then return; the following day would see the No. 19 lead a train to Hambone, where it would turn back to McCloud while the passenger cars continued on to Lookout and back at the end of a freight. The photograph below shows the train on April 30 rolling through the forest near Obie. (Above, Travis Berryman photograph; below, Jeff Moore photograph.)

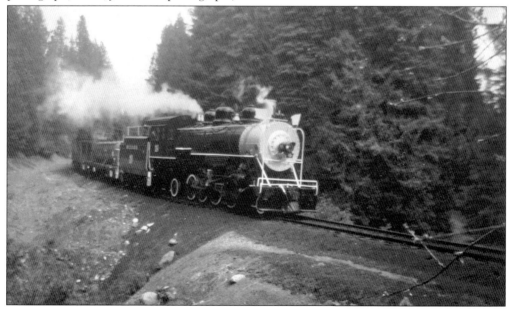

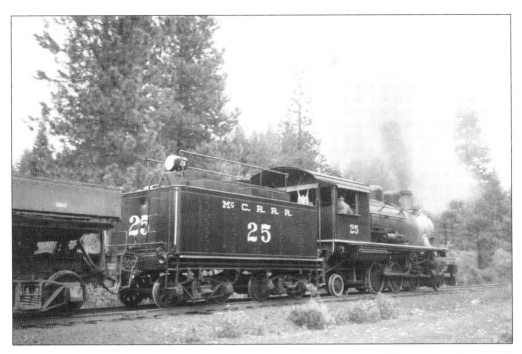

The McCloud Railway acquired the No. 25 from a private party in 1995. Two years of shop work brought the old locomotive back into operation in time for the Labor Day weekend in 1997. The above photograph shows the No. 25 rolling another Trains Unlimited Tours charter that includes a short freight at Bartle, while the photograph below depicts the No. 25 with a Civil War reenactment "Troop Train" in the midst of a battle at Signal Butte. (Above, Alicia Moore photograph; below, Roger Titus photograph.)

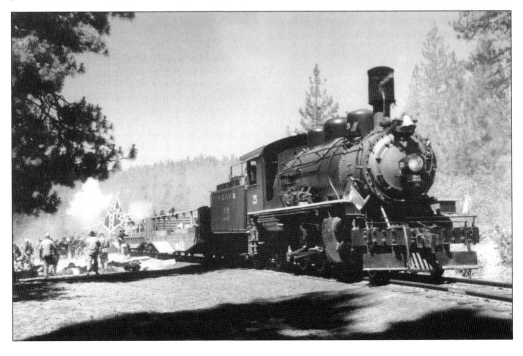

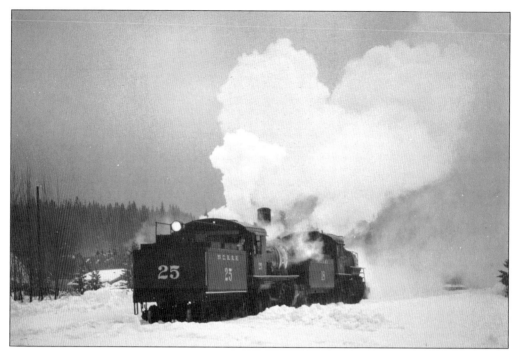

In the summer of 1998, the Yreka Western announced it would sell its locomotive No. 18, formerly McCloud River No. 18, at auction. The McCloud Railway beat out two other bidders and brought the old locomotive home. The McCloud shop finished restoring the locomotive in time for a double-headed excursion with the No. 25 in February 2001. The two locomotives are seen above rolling through the McCloud yard and then below arriving at Bartle. (Above, Travis Berryman photograph; below, Roger Titus photograph.)

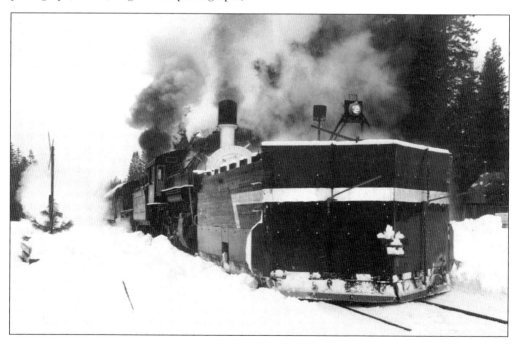

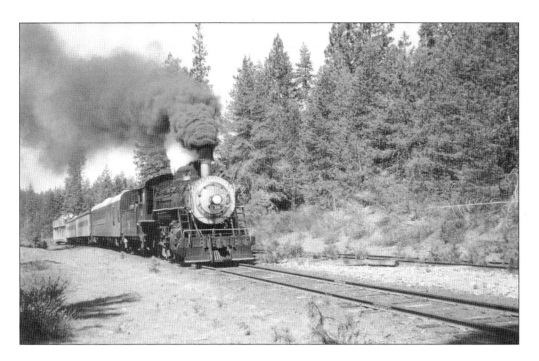

The early 2000s would see several trips become yearly events, such as Memorial Day and Fall Foliage trips to Burney and Fourth of July and Labor Day trips to Mount Shasta City. Memorial Day 2002 found the No. 18 putting on a show for railfan photographers at Curtis (above), while a rainy day in May 2003 saw the locomotive leading a special photograph freight (below) made up of old fire and ballast cars. (Above, Alicia Moore photograph; below, Travis Berryman photograph.)

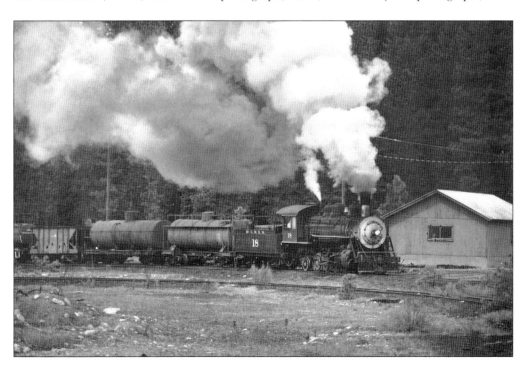

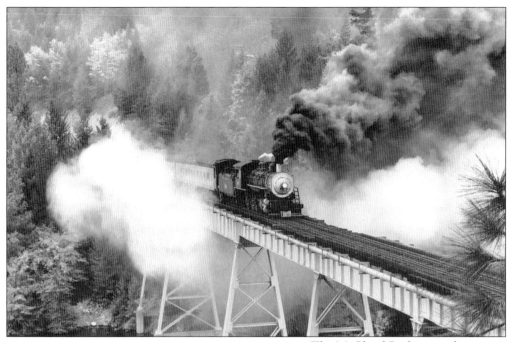

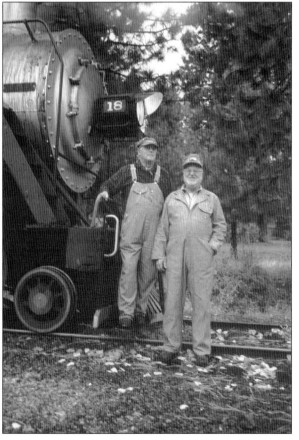

The McCloud Railway made a valiant effort to keep the steam program going, but in the end the economics just did not work out. In late 2004, the railroad placed the No. 18 up for sale and announced that the Fall Foliage trip to Burney scheduled for October 18 might be the last use of steam on the railroad. The No. 18 is seen above posing for photographs on the Lake Britton Bridge on its last trip to Burney; the image at left depicts conductor Roger Titus (left) and engineer Malen Johnson on the No. 18's pilot after returning to McCloud. (Above, Roger Titus photograph; below, Travis Berryman photograph.)

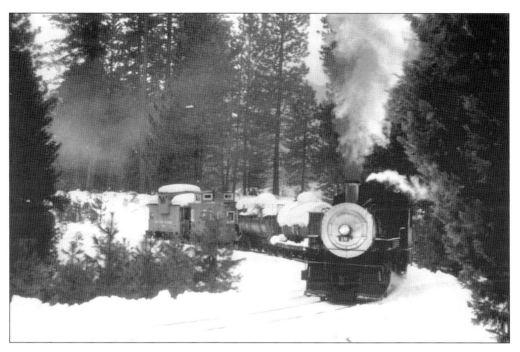

Shortly after the October run, a railfan organization announced that the No. 18 would run at least one more time. The weekend of January 15 and 16 found the No. 18 hot again, with a privately chartered photograph freight on the Mount Shasta line on January 15 (above), followed by the public excursion to Bartle and back the next day. The No. 18 cut off of the train to do some work with the snowplow for photographers on the moribund Hambone line (below). (Above, Roger Titus photograph; below, Travis Berryman photograph.)

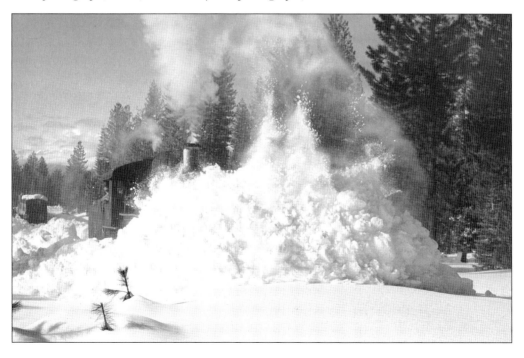

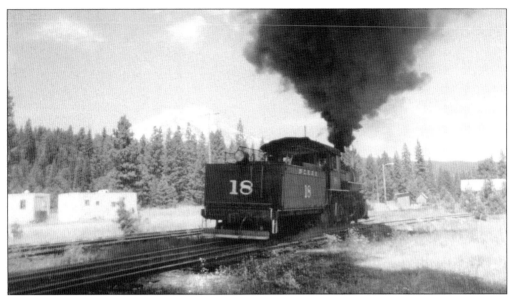

In January 2005, the McCloud Railway announced that the No. 18 had been sold to the Nevada Commission for the Reconstruction of the Virginia and Truckee Railway, which is rebuilding a portion of the fabled V&T Railroad in western Nevada. The summer of 2005 saw several more "last runs," with the last of the last finally coming on a Sunday in early August. The No. 18 (above) makes one last run for some photographers before going into the shop and dropping its fires for the final time. A return visit a year later finds the No. 18 and the No. 25 slumbering in the back of the shop building (below). The No. 18 would finally leave the property in April 2007; as this book goes to press the No. 25 has been returned to service and has received some cosmetic alterations for some possible movie work; it faces an uncertain future in McCloud. (Jeff Moore photographs.)

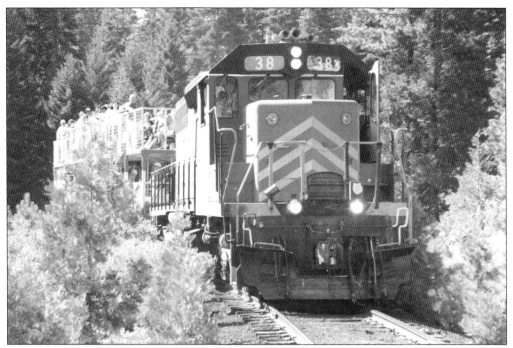

The McCloud Railway operates this open-air excursion train from McCloud to Signal Butte and back on some summer afternoons. The McCloud shop crew created the unique double-backed excursion car in 1998; it has a silver and red paint job that matches locomotives Nos. 36 and 37. (Roger Titus photograph.)

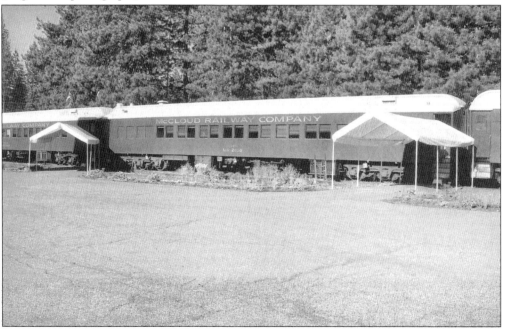

An early morning in August 2005 finds the Shasta Sunset Dinner Train waiting for the crowds that will start to arrive in the early evening. The parking lot occupies the space once held by the McCloud depot building. (Jeff Moore photograph.)

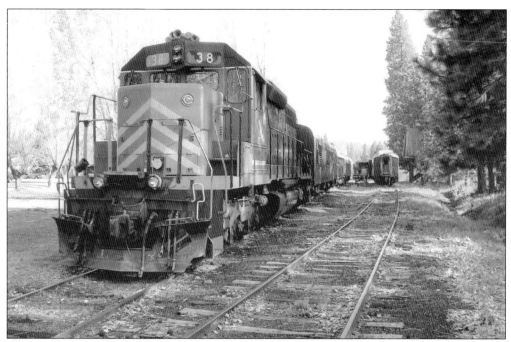

An early evening in May 2007 finds the No. 38 coupled to the dinner train; the 6 p.m. departure time is only a few minutes away. (Jeff Moore photograph.)

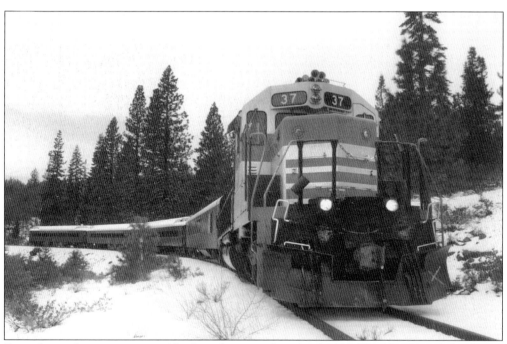

Snow from a late-season storm blankets the ground in April 2003. The No. 37 and the dinner train are disturbing the solitude at Signal Butte. (Roger Titus photograph.)

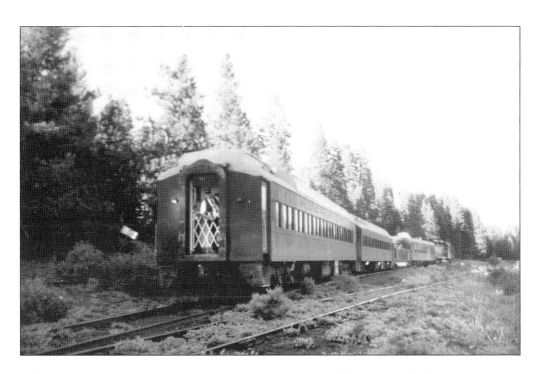

The Shasta Sunset Dinner Train has proved to be a commercial success, with the train expanding from one to four cars in a year's time. The operation has become the centerpiece of McCloud's efforts to transition from a timber town to a major tourist destination. The train is seen here in two more shots, one at Pierce (above) and again at Big Canyon (below). (Above, Jeff Moore photograph; below, Roger Titus photograph.)

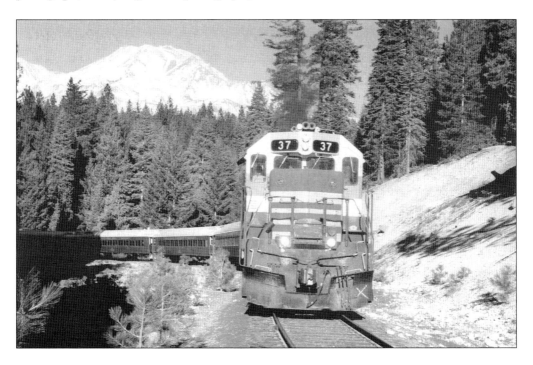

Across America, People are Discovering Something Wonderful. Their Heritage.

Arcadia Publishing is the leading local history publisher in the United States. With more than 4,000 titles in print and hundreds of new titles released every year, Arcadia has extensive specialized experience chronicling the history of communities and celebrating America's hidden stories, bringing to life the people, places, and events from the past. To discover the history of other communities across the nation, please visit:

www.arcadiapublishing.com

Customized search tools allow you to find regional history books about the town where you grew up, the cities where your friends and family live, the town where your parents met, or even that retirement spot you've been dreaming about.